Indian Basketry

Indian

An Exhibition circulated by the
SMITHSONIAN INSTITUTION TRAVELING EXHIBITION SERVICE

This Exhibition is jointly organized by the Bowers Museum Foundation and the City of Santa Ana and supported by a grant from the National Endowment for the Arts.

Basketry

of Western North America

From the Collection of the
BOWERS MUSEUM, SANTA ANA, CALIFORNIA

CHARLES E. ROZAIRE, Guest Curator

BROOKE HOUSE, Los Angeles, California

Copyright © 1977 by the Bowers Museum

Library of Congress Cataloging in Publication Data

Charles W. Bowers Memorial Museum.
 Indian basketry of Western North America, from the collection of the Bowers Museum, Santa Ana, California.

 Catalog of an exhibition jointly organized by the Bowers Museum Foundation and the City of Santa Ana and circulated by the Smithsonian Institution Traveling Exhibition Service.
 Bibliography: p.
 1. Indians of North America—The West—Basket making—Exhibitions. 2. Charles W. Bowers Memorial Museum.
 I. Rozaire, Charles E., 1927– II. Smithsonian Institution. Traveling Exhibition Service. III. Title: Indian basketry of Western North America . . .

E78.W5C47 1977 746.4'1 77-331
ISBN 0-912588-39-X pbk.

7890123987654321

Design by Barbara Monahan
Figure 1a by Frances Runyan
Composition by Camera-ready Composition
Printing and Binding by Alan Printing & Litho, Inc.

Distributed in Canada by Van Nostrand Reinhold, Ltd.

CONTENTS

FOREWORD

The North American basket collection of the Bowers Museum is one of the most important and complete collections in the United States today. One hundred twenty-eight examples selected from the collection are illustrated and discussed in this book prepared in conjunction with a traveling exhibition of one hundred of these pieces being circulated by the Smithsonian Institution Traveling Exhibition Service.

Through acquisition efforts, the Bowers Museum Foundation has attempted to gradually upgrade the quality of the Museum's collection. In 1934, expansion of the collection began with the loan of many important southwest American Indian baskets from the Mary J. Newland Collection. In recent years, the Bowers Museum Foundation has been able to add several important examples to areas of the collection not previously represented. This collecting effort continues as a challenge to the Foundation in hopes of eventually having one of the most important and complete collections in the world based on the quality of selection.

The baskets selected for this exhibition and represented in this book have never been publicly displayed before. Twenty-six tribal areas are represented by examples which were selected for types of weave, technique, and function best illustrating the overall panorama of each culture.

REILLY P. RHODES
Museum Director

ACKNOWLEDGMENT

This book is published in conjunction with the circulating exhibition *Indian Basketry of Western North America* from the collection of the City of Santa Ana / Bowers Museum, Santa Ana, California, under the auspices of the Bowers Museum Foundation, Inc. and with the generous assistance and support of the National Endowment for the Arts in Washington, D.C., and the Smithsonian Institution Traveling Exhibition Service.

We are fortunate to have the services of Dr. Charles E. Rozaire, Curator of Archaeology, Los Angeles County Museum of Natural History, as the Guest Curator for the exhibit. For many months, he worked on the catalogue information and text material and, with the assistance of Reilly P. Rhodes, the Museum Director, selected the best and most characteristic pieces from the collection and, with this exhibition in mind, advised the Foundation in making some major acquisitions. We are indebted to Kenneth Donahue, Director of the Los Angeles County Museum of Art, for his encouragement to utilize and exhibit this collection of Indian baskets of North America. The Trustees and Board of Directors also wish to express special thanks to Dr. and Mrs. Milton D. Heifetz of Los Angeles for the loan of their two fine Pomo feathered baskets illustrated in color in this book. The Bowers Museum is also grateful to Bob Corey for his encouragement, advice, and counsel in the Museum's efforts to publish this book.

We thank Stuart Weiner for his special efforts in providing excellent color and black and white photographs and Jerry Muller for his fine black and white photographs. Preparations for this catalogue were made much easier because of the excellent supportive work performed by many other staff members and volunteers, particularly Margaret Key and Jeane Whitley, who were responsible for catalogue labeling and the catalogue section of this book, and Patrick Alt, who handled these many objects during their installation and preparation for circulating purposes.

Our Museum was fortunate in receiving matching funds for exhibition support from the National Endowment for the Arts. The endowment's grant allowed us to mount this exhibition and to research the material brought together in this book.

JOHN R. HILSABECK, M.D.
President, Bowers Museum Foundation

INTRODUCTION

In all human cultures, woven artifacts are found showing endless variations in technique and quality. String and rope reinforced with knots and used for lariats, bows, nets, and similar objects date even earlier than the Neolithic era. Radiocarbon analysis dates basketry objects found in Nevada, Utah, and Oregon incorporating fairly complex techniques of coiling, twining, and false embroidery at between 9000 and 7000 B.C.

Discoveries in pre-Dynastic Egyptian burials attest to the widespread use of basket work as early as the 4th and 5th centuries B.C. Baskets have been found woven from entire leaves or from thin strips of date-palm leaves sometimes reinforced by intermediate ribs made of date-palm branches. In some geographic locations, the doom palm was more often used for baskets. In Egypt, the remains of the oldest funerary mats and basket work coffins also go back to the pre-Dynastic era; some were made of rushes or papyrus stems, others of cane. The fibers were woven in rows intercepting at right angles to form a reticulated fabric, and in the more elaborate examples, a herringbone ornament done in parallel strokes is applied on a plain background. The Theban tombs of the New Kingdom have yielded many basketry artifacts, such as mats, baskets, boxes, caskets, and sandals, objects of common use with no particular pretense at aesthetic elaboration other than an occasional geometric design obtained by two-color combinations of red and black dyed fibers. The raw materials were not varied with the passage of time except for the later addition of alpha grass to those already mentioned.

Both the representational arts and literary sources in Egypt are rich in indirect documentation of basket work. In ancient Southwestern Asia, impressions of mats have been found in excavations almost everywhere, the most important being at Ur. Literary sources, the Bible in particular, give evidence of the development of basketry in the ancient East. *The arc of bulrushes* in which the infant Moses was hidden among the flags by the river's edge is perhaps the most dramatic documentation. Baskets were used to bring the tithes to the temple at harvest time, and in a vision, the prophet Jeremiah saw *two baskets of figs* placed *before the Temple of the Lord.* Matthew talked of *twelve basketsful.* The use of baskets must have been very widespread in protohistoric agriculture and especially in pastoral cultures of

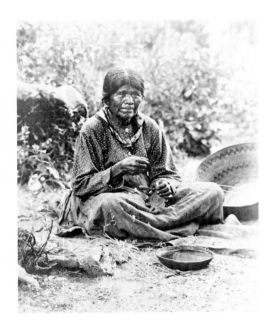

the Eurasian and Mediterranean world. In the *Odyssey*, baskets for cheese are referred to in the incident concerning Polyphemus. Also, small bronzes from Sardinia faithfully reproduced baskets and panniers. One of the most remarkably clear pictorial documents of ancient Greek times, the *laconian cup of Arkesilas*, shows goods being bailed and weighed in basketwork receptacles.

It is evident, however, that in the flowering of classical civilizations, the art of basketry must have declined to a mere craft since ancient authors considered these objects a product characteristic of barbarian peoples. Nonetheless since its earliest beginnings, the art of basketry has flourished, particularly in the primitive cultures. A people who lived in the Southwestern United States made some of the finest examples of basketry in the world. In fact, the craft had such an important place among them that archaeologists and anthropologists have named them the "basket makers." They made their best baskets by coiling, but they also made sandals, mats, and shallow bowls by twilling. Their successors, the ancestors of the Pueblo Indians, continued the tradition until about 1300 A.D.

In the 19th and early 20th centuries, the tribes in California, the Southwest, and the Northwest, including Canada and Alaska, made some of the finest baskets known from any era. Other important centers for production have been and continue to be in Japan, China, and Indonesia.

R.R.

A CURATOR'S NOTE

Background

Basketry represents a vital aspect of American Indian life from the standpoint of survival as well as artistic expression. Along with the working of stone and bone, basket making was probably a basic technological skill that came with the first occupants of the North American continent. Due to the inherent perishable nature of the material, basketry remains are rarely found associated with the indestructible stone and more durable bone tools. However, a respectable antiquity has been established by radiocarbon dating to go back more than 10,000 years, which establishes a time horizon for the beginnings of some of the earliest recognized cultural traditions in the New World.

Desert areas and dry caves afford the best places for preservation, so it is not too surprising to learn that the earliest examples are to be found in the Great Basin region of the western United States. The weaving technique so far dated as being the first is that of twining, where the moving elements (wefts) twist around the foundation elements (warps). Several thousand years later, the coiling method of weaving comes into being; a hard or soft core element (coil) is wound around and around in spiral fashion and held in place by thin wrapping elements (stitches). The latest technique is that of plaiting, where the warps and wefts merely go over and under each other in a particular pattern from simple to complex. So far, the foregoing sequence applies just to the Great Basin area where our only evidence currently exists, but it might apply to the general pattern of American Indian technological change and development.

Basketry technology affords great insight into the historical and cultural relationships among groups both in the present as well as the past. In working out distributions of the three basic techniques of twining, coiling, and plaiting, large regional variations occur and significant differences can be noted within each region when details are observed. Thus in broad general terms, the northwestern portion of the North American continent is dominated by twining, the eastern portion of North America by plaiting, and the southwestern region of the United States by coiling. This outline is not clear-cut due to pocket occurrences of other techniques and the use of more than one by certain groups. Thus, for the Pomo of California, all techniques were known; for the Hopi of Arizona, both coiling and

Figure 1 TWINED WEAVING

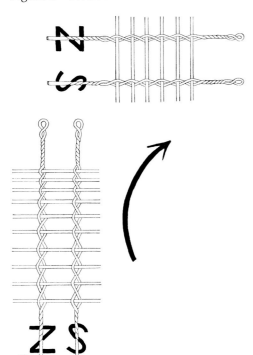

1a Plain Z-twining and plain S-twining

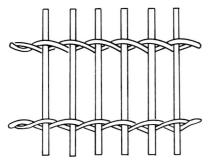

1b Plain twining

plaiting are common in the making of plaques; and among the Washo of Nevada, coiling and twining are well practiced, the latter technique usually reserved for basketry of hard usage in their food gathering activities.

Weaving Techniques

TWINED WEAVING of basketry is the most widely known technique for western North America. Its greatest popularity, if not exclusive use, is among certain groups along the coast extending from the Aleutian Island chain down southern Alaska through British Columbia, and southward to Washington and Oregon, and into northern California. Twining is also important in the Great Basin. Elsewhere where coiled containers predominate, the weave is limited to special uses, such as water "bottles" or burden baskets.

The twined technique involves the twisting of weft elements *around* warp elements, and this can be accomplished in quite a variety of ways and patterns. Each group has established certain weaving traditions which have been passed down and carried on; therefore, an examination of the weave offers clues as to the group to which the basket can be attributed.

Because at least two elements are involved in twining, the twist results in a lean of the stitch either up (down) to the right (left) or down (up) to the right (left) and, once established, appears to be the ingrained tradition for the group. Thus the Klamath and Modoc twine down to the right while their neighbors, e.g., the Shasta, do just the opposite (up to the right). In describing this feature, one can use the letters S and Z, referring to the slant of the central portions of these letters, which also is applicable to the direction of spiral twist in cordage (see Figure 1a).

When the wefts pass around a single warp or consistently around the same multiples of warp elements, the weave is known as *plain twining* (Figure 1b). When one weft is continuously left on one side of the warp while the second element is wrapped around the other weft and a warp, the technique is *wrapped twining* (Figure 1c). When two, or conceivably more, warps are enclosed alternately in successive rows up the basket, the weave is called *twill* (sometimes diagonal) *twining* (Figure 1d). Twill twining is most often seen in heavy-duty work baskets.

Three weft elements are also used in twining, usually for strengthening the basket and/or for a decorative effect. For three elements there also is a lean of the stitch in one direction or the other, but with the added potential of braiding (braided twining) along with plain twining.

Workmanship and fineness of weave, determined by number of warps and wefts per square inch, will vary depending on the kinds of material available and the extent to which they are prepared, the function of the basket, and the skill of the weaver. Closely woven examples predominate, but open weaves can serve very adequately and do in certain instances: a necessity in the case of sifters and leaching baskets and the potential elimination of unnecessary weight in some burden baskets.

Among the most finely woven twined baskets are those produced by the Aleuts. Made of very thin split wild rye or other grasses, the baskets include examples having among the most warps and wefts per unit of measurement. Because the warp as well as the weft is comprised of soft grass, the weaving is done with the basket suspended downward from a fixed support above to allow gravity to maintain the warps in their proper relationship. Because of the flexible nature of all the raw materials, the result is almost clothlike in texture. Unfortunately, on being removed from the natural humid climate of the Aleutian Islands, the fibers of the basket may tend to dry and then crack, and perhaps even to disintegrate, if not properly handled or cared for.

The more usual method of twining is carried out by weaving upward and is practiced by most other western North American Indian groups. The foundation elements range from soft, flexible roots and stems to stiff twigs which may be whole or split. Klamath and Modoc baskets have the warps twisted into cordage; this results in very flexible sides, especially when compared with examples from their surrounding neighbors. Cordage warps are also found in the bags and containers of the Nez Perce and Wasco.

The basket may be started in several ways, such as crossing warps radially, plaiting them, or arranging lengths of warps in U-shapes, sometimes overlapping them. The finish can be accomplished by a simple trimming of the warps just above the last weft row or by elaborate braiding of the warp ends in a variety of patterns. The types of rims formed by these procedures can be additional clues to identifying the tribal origin of these baskets.

COILED WEAVING of basketry is a technique most commonly used by groups in the southwestern United States and southern California, but includes important regions in Alaska, interior British Columbia and Washington, and to some extent the Great Basin.

The coiled method of weaving involves the forming of a foundation (or coil)

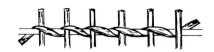

1c Wrapped twining

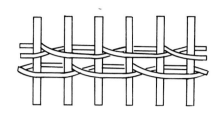

1d Twill twining

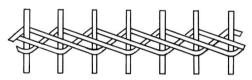

1e Plain 3 element twining

Figure 2 COILED WEAVING

2a Interlocking stitch

2b Non-interlocking stitch

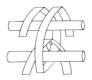

2c Split stitch

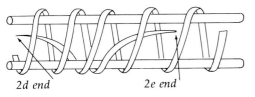

2d end *2e end*

2d Termination of stitch
2e Beginning of stitch

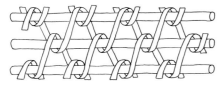

2f Single rod foundation

which then is made to spiral outward while being covered and held together by stitches which completely encircle and sew into the continuous coil foundation. The materials used to make up the coil are varied, ranging from bunches of grass to single twigs or rods; these in turn occur in different numbers, combinations, and positions. The stitches wrapped around the coil can be held together, along with the coils they form, in several ways: by interlocking, non-interlocking, and split stitches (see Figure 2).

Where documentation is lacking, clues as to tribal origin can be found by observing, among other things, the nature of the stitching, the direction of the weave (coil), the side of the work surface, how the basket is started and the rim is finished, along with the raw materials employed and how they were prepared and used. Design elements and the method of forming the decorative motifs are other obvious indications for attribution.

In the course of weaving coiled basketry, a sharp pointed awl usually has to be used to pierce the coil so that the stitch can pass through. In vertical rod basketry, the stitches go around the coil, but an awl can facilitate passage between the rods.

PLAITED BASKETRY is most common in the eastern United States and tends to be limited in western North America, being found only in special varieties of baskets of some tribes. As a technique in the western region, plaiting may also be introduced simply as an adjunct weave to twining for decorative effect or as a convenient way to start a twined basket (Figure 3). Its use is found more frequently in the Northwest Coast area and among the Pueblo groups in the southwestern United States for carrying baskets, plaques, and sifters.

In plaiting, the warp and weft elements pass simply under and over each other. With the weaving elements being of the same width and crossing over one and under one, the visual effect is one of a checkerboard and can be called plain plaiting (Figure 3a). However, pleasing variety can be made easily by changing the number and pattern of warps and wefts and also the widths of each. When more than one element is crossed, the weave is called twilled plaiting (Figure 3b).

The Making of a Basket

The finished basket represents a great achievement on the part of the weaver and reflects an impressive background of knowledge and skill.

Before the basket construction can begin, the weaving elements have to be gathered, requiring much time and effort not only in the careful selection of choice raw materials, but in the travel needed to get back and forth to the favored locations. In order to be used, the plants have to be collected just at certain periods of the year, and only that vegetation can be gathered which has reached a particular point in its growth cycle.

Once the materials have been assembled and before weaving can be started, there usually has to be some preparation in the form of cleaning, stripping, splitting, and/or treatment by applying heat or liquids; and these procedures are also quite time-consuming, especially when preparations are complicated. In some areas, the roots of plants are specially treated by heat, such as by being buried in hot sand for a day or so, in order to make them pliable and more durable. Occasionally the fibers may be twisted into cordage for warps and/or wefts. Stems, shoots, and twigs more often than not are split, necessitating great skill to produce long as well as even-sized weaving elements. For colors, dyes may have to be prepared, or the materials may be treated directly, such as by being buried in mud to achieve a black color.

With all the materials prepared, the basket weaver must conceptualize the final product and thus possess a fine sense of symmetry, balance, and proportion in relation to form and have good artistic taste to be effective in picturing relationships of design and color.

Working out the design of the basket is probably the most difficult aspect of the weaver's work, requiring careful, concentrated effort. The gathering and preparing of materials is a routine task which involves little thought, and the weaving technique itself becomes a learned mechanical operation. However, the placing of a pattern on a basket raises special problems which put great demands on the weaver's mental abilities. Each basket is a unique creation and presents a whole new series of challenges that have to be met. Lila O'Neale states that when the Yurok-Karok basket makers plan or start a basket, the "good weavers send the children out of the house while they wrestle with the problem. To talk at this stage is out of the question even for the women who ordinarily work as well in a sociable group as alone."

Designs must be fitted properly to the size and shape of the basket and must be conceptualized completely before the work is started. For all the elements to work out evenly, there has to be a sense of mathematical proportion and symmetry with accurate calculations. The weaver has to keep in mind constantly the details of

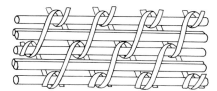

2g Three rod triangular foundation

Figure 3 PLAITED WEAVING

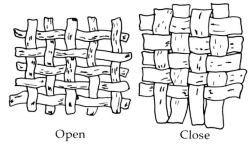

Open Close

3a Plain plaiting

3b Twilled plaiting

the various elements of the pattern: where they are placed, how they are placed, their relationship to each other as the weaving progresses, and how they will be related to the overall effect on the finished form. The variations in length, size, and shape of the design and the spaces between require numerous permutations and intense concentration. It is all the more impressive when one realizes that in many cases the weaver cannot keep track visually because the opposite part of the basket is not always in view. Situations must be foreseen, and if an error occurs, it can grow; if the weaver declines to take out the stitches in error, there will be special demands on ingenuity to make necessary corrections and adjustments later. For truly quality work, the weaver does not begrudge the time nor patience required to be flawless in the arrangement of the design motifs and spaces with the form in order to achieve the perfect balance which makes the basket so attractive and an outstanding work of art.

The finished basket is usually a marvel in geometric and mathematical perfection—which is made all the more remarkable considering the lack of precise instruments and the reliance on just the eye and rough, crude measurement. This situation speaks well for the high artistic quality of the weaver's abilities, especially when one notes the technical perfection achieved.

When there is some sort of "flaw" in what otherwise might appear to be a perfect design, it can usually be understood in the context of style. If not, it can be understood in a context appealing to the imagination or to aesthetic feeling, when one realizes there may be some aspect of symbolism or some compelling belief to explain the situation. For example, the insertion of a series of quill stitches into the coiled Pomo basket is an indication of the weaver's desire to continue her work during a menstrual period, which would be bad luck without substituting bird quills for plant materials. Another example is the lack of a completed circle as a pattern in the Navajo wedding basket. The line is believed to allow the spirit of the basket to pass freely in and out; once understood, the opening line is not jarring to the senses. Knowledge of the weaver's concepts and motives can go a long way in providing greater appreciation of the efforts put forth.

CHARLES E. ROZAIRE, PH.D.

1 July 1976

Indian Basketry

2

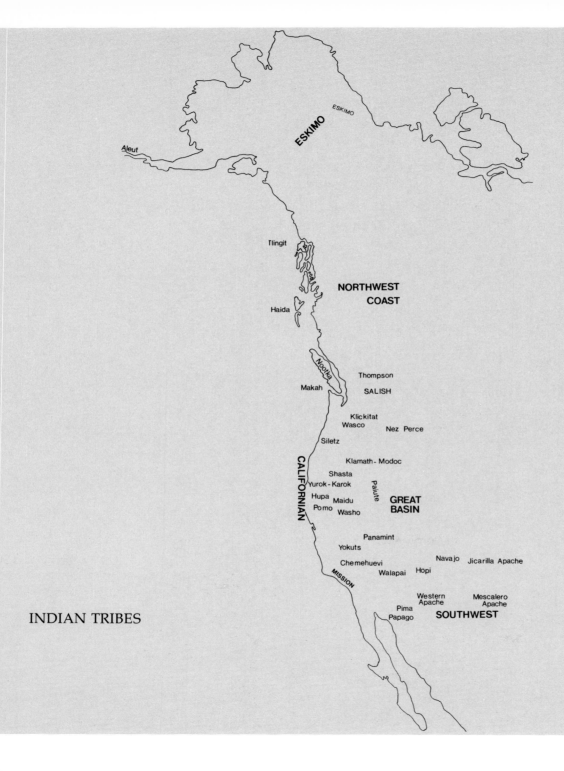

ESKIMO

ESKIMO

Aleut

Tlingit

NORTHWEST COAST

Haida

Nootka

Makah

Thompson

SALISH

Klickitat
Wasco

Nez Perce

Siletz

Klamath - Modoc

Shasta

Yurok - Karok

Paiute

Hupa

GREAT BASIN

Pomo Maidu

Washo

Panamint

Yokuts

Chemehuevi

Navajo Jicarilla Apache

Walapai Hopi

MISSION

Western
Apache

Mescalero
Apache

Pima
Papago

SOUTHWEST

CALIFORNIAN

INDIAN TRIBES

ESKIMO

The Alaska Eskimo produce coiled basketry which many times has been very carelessly woven with uneven foundation and erratic stitching, resulting in uneven symmetry and rough surfaces. However, there are examples of careful workmanship in their basketry (see Plate 1), and the consistency of fine skill in sewing is obvious in the invariably excellent quality of embroidery using furs, intestines, and quills.

Wild grasses make up the raw materials of Eskimo basketry. It tends to take form in globular shapes with many being topped by a conical knobbed lid; in the absence of a basketry knob, the Eskimo may add a piece of carved stone or ivory as a handle. They may introduce dyed grass and/or strips of skin or cloth for surface design. Originally, they produced dyes from natural materials, but after contact with Europeans, they used commercial aniline dyes which tend to fade.

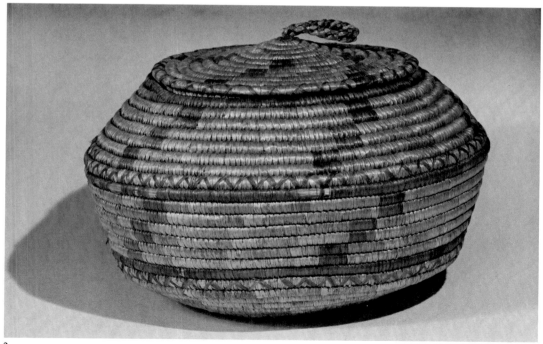

1
TALL LIDDED STORAGE BASKET
See p. 17

2
LIDDED STORAGE BASKET
10½″ diameter, 6½″ high. Coiled basket construction utilizes native grasses. The decoration is with grasses dyed blue, red, and orange, which have faded. The original colors are visible in the interior of the basket and lid.

ALEUT

3
LARGE STORAGE BASKET
WITH KNOBBED LID
See p. 18

The Aleuts produce the finest and most delicate weaving of North American Indians. Their basketry is distinguished by its consistent fineness of Z-twined weave and the light, flexible nature of its construction. The weave may be so close that some baskets resemble fine linen or grosgrain silk, the number of stitches to the square inch being almost double that of other Indian baskets. In addition to overall closely woven examples, an open weave occurs with the crossing of warps as the main technique to construct some baskets or for decorative effect in part of other baskets.

In the Aleutian Islands, the long days of the brief summer produce an abundance of grass which is gathered, dried, and split many times to provide material to make the delicate basketry. For decoration, the false embroidery technique introduces colored silk thread and/or fine worsted yarns in beautiful geometric and floral designs; many of these designs show early Russian trade influence.

A very popular form is the cylinder. When lids occur, they are usually knobbed.

TLINGIT

4
STORAGE BASKET WITH
LIDDED "RATTLE TOP"
See p. 19

5
STORAGE BASKET
7" diameter, 5¾" high. This basket weave utilizes spruce roots in plain, 2 element Z-twined technique. Four lines of 3 strand twining strengthen the sides. The decorations in the false embroidery technique are of dyed grasses and maidenhair fern stems.

The Tlingit, who are residents of southern Alaska, make tightly Z-twined basketry. Twining with ten stitches per inch is average, basketry having twenty is considered very fine, and that having thirty stitches per inch could be seen as a rare treasure. Some baskets are also plaited. The Tlingit may combine plaiting with twining, many times on the bottom, alternating with twined rows, or on the sides for decorative effect. Occasionally warps cross to produce an open weave.

The Tlingit favor the spruce root for the basic weave. The false embroidery technique is employed for decoration with maidenhair fern stems used for a glossy dark brown color and dyed grasses for such colors as white, yellow, and orange.

Originally, the Tlingit used vegetal dyes, but after 1890, they replaced them with the more easily used aniline dyes.

The design in false embroidery is produced by wrapping the grass or fern stems around the weft strand so that the pattern shows only on the outside of the basket. The nature of the wrapping in the "embroidery" technique makes the slant of the grass opposite to that of the weft. This ornamentation adds some strength to the basket.

The enclosed inverted "U" shapes in brown and yellow-orange are an old motif known as "wave" pattern, representing the rise and fall of a floating object. The sequence of blue-green geometric triangles is called "spear barb." The blue-green coloring results from the boiling of hemlock bark in urine combined with scrapings of copper oxide. The intervening series of stepped elongated rectangles in brown separating the upper and lower band designs is known as "winding around" or "tying," representing the wrapping of a belt around the body.

6
SMALL STORAGE BASKET
5" diameter, 3¾" high. This basket weave utilizes spruce roots in plain, 2 element Z-twined technique. The decoration is maidenhair fern stems in false embroidery. There are four birds in the central panel; a darker brown step pattern called "spirit around the head," always used on basketry hats of shamans, who are medicine men, encloses the birds at the top and bottom. An old and popular design, it has been described as indicating a mountain range as it descends to water. Zoomorphic designs are not common in Tlingit baskets.

7
SMALL CONICAL STORAGE BASKET
2½" diameter base, 4½" diameter top, 3¼" high. This basket weave utilizes spruce roots in plain, 2 element Z-twining. The decoration of four interlaced bands of grass dyed red in false embroidery technique is another variation of the old and popular "wave" pattern. Red was one of the favorite colors used by the Tlingits and came in various shades according to the materials and method of dyeing used. They used urine as a mordant in which to steep alder wood, nettle leaves, or hemlock bark to obtain the desired shade of red. A row of plain, 3 element Z-twining is along the bottom edge and the top rim.

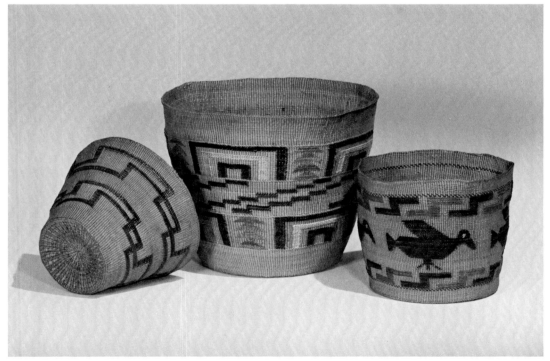

5 center, 6 right, 7 left

8

SPOON BAG
9" across top, 5⅞" long. This weave utilizes
spruce roots in plain, 2 element Z-twining
with crossed warp open weave occurring in
two bands, called "eye holes" by the Tlingit.
False embroidery using dyed grass and
maidenhair fern stems is the technique of
decoration.

This flat case hung on the wall to hold
eating spoons which were probably of horn.
The design motif in orange and black at the
top and bottom may be a variant of the "half
cross." The weaver possibly reproduced the
swastika from a southwestern U.S. Indian
illustration or from a blanket design traded to
the group by the Hudson's Bay Company.

9

BASKETRY RATTLE (?)
5" diameter, 11" long. An unusual
composite-shaped basket with a lid at one
end has a weave with split spruce root in
plain, 2 element Z-twined technique. The
decoration is by false embroidery using
yellow, red, and green dyed grasses. The
designs are variations of "a feather wings of
the arrow" and "half the head of a salmon
berry." It is said that this basket was a rattle.
The basket contains small shells which rattle
when shaken. A Tlingit woman of Sitka,
Alaska, made this basket.

10

LIDDED JAR-SHAPED BASKET
See p. 20

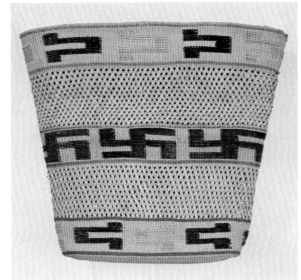

8

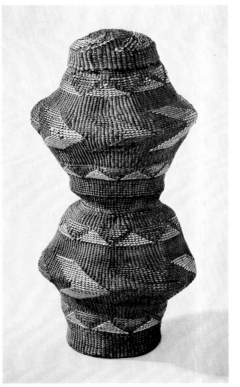

9

HAIDA

The Haida centered on the Queen Charlotte Islands of British Columbia, Canada, and have been considered the most outstanding group of carvers, weavers, and builders of the Northwest Coast Indians. They carved impressive totem poles, constructed spacious dwellings of huge cedar beams and planks, and hollowed out large logs which they shaped into canoes. These canoes enabled them to hunt sea mammals and travel between villages.

Haida basketry is very well made and closely resembles that of other Northwest Coast tribes. All are Z-twined and of spruce root, with grasses for designs applied in the false embroidery technique. In addition to geometric patterns, on occasion the Haida also wove in designs of naturalistic forms. They wore wide brimmed, conical basketry hats with flattened tops as important status symbols; they painted colorful motifs of stylized animals on these hats. One way of weaving was to attach the start of a basket to a pole and then weave the body of the basket from this upside-down position.

11
CEREMONIAL HAT
See p. 21

SALISH (INTERIOR)

The Salish-speaking peoples were concentrated in the southern portions of British Columbia and extended into Washington state. Although linguistically related by nearly forty dialects, the Salish had strong regional differences which made it convenient to designate these groups culturally as Coastal, Interior, and Plains subdivisions.

In terms of basketry, the Interior Salish form a special unit along with some of their neighbors of other linguistic derivation, in particular the Sahaptin-speaking Klickitat. When tribal documentation is lacking, there is a tendency to classify basketry from the region by the name Salish or Klickitat. The coiled basketry is distinctive and immediately recognizable by the overall surface decoration of imbrication and beading which involves the addition of colored materials into and

over the basic stitches that go around the coil. Despite an extensive report written on this basketry by Franz Boas in 1921, regretfully the potential definitive information for delineating tribal identities was lessened by the untimely deaths of two early researchers on the subject and by the loss of identification of illustration and museum numbers.

Because cedar is the basic material of this coiled basketry, this type of weaving coincides with the distribution of this plant along the great river valleys of the Thompson and Fraser as well as smaller valleys to the south. Splints of cedar or bundles of cedar roots and/or grasses make up the coil materials. Wide, flat surfaces characterize the basketry using splints of cedar and provide a convenient rigid form for carrying burdens or packing items. A rounded, ridged surface distinguishes the basketry using cedar roots and/or grasses; because of the weaver's ability to get a tighter weave, the Salish could also use baskets made in this manner for containing liquids and for cooking. The fibers would swell with moisture and become water tight; then the Salish would place heated stones in the basket to cook food. The early basic shape for all groups was circular; gradually it changed to more oval and then to rectangular, but these later forms never replaced entirely the early rounded forms in all areas. The angular-cornered examples may reflect the influence of wooden boxes which were made on the coast.

12
SMALL STORAGE BASKET
11¾" long top, 8¼" wide top, 7¼" high. Coiled basket has imbricated decoration in red, split cherry bark; white, natural reed; and black, dyed reed. The imbrication technique adds rigidity to the basket. During the late 1800's, the rectangular shape became typical. The "stepped star" and "cross" motifs dominate the imbricated design.

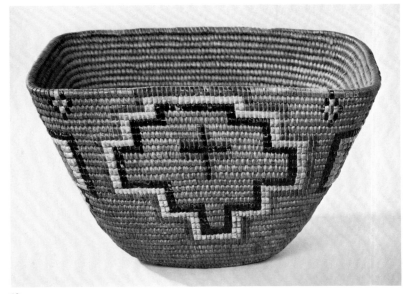

12

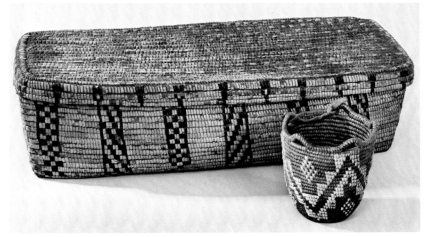

13 *bottom,* 14 *top*

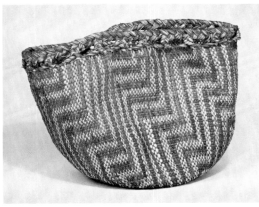

15

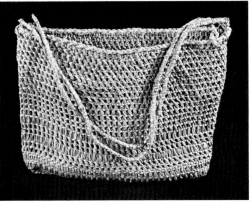

16

13
SMALL STORAGE BASKET
4¾" diameter, 4¾" high. Coiled basket has imbricated design in natural white-colored reed materials. The motifs are called "ladder" and "diamond." Once a strip of leather encircled the basket rim; this was a common feature of this type of basket.

14
RECTANGULAR LIDDED STORAGE BASKET
22" long, 10¼" wide, 6" high. Coiled basket has imbricated decoration. Construction shows the use of slats for foundation in bottom and lid. The rectangular wooden boxes of the coastal peoples may have influenced the shape.

15
CARRYING OR HARVEST BASKET
15" diameter, 13" high. Construction of native grasses is in plain plaiting with twill plaiting start at bottom. There is a braided rim. The flexible warp enables the basket to be folded flat when empty.

16
FLEXIBLE CARRYING BASKET
13" wide, 10" high. Twined basket has crossed warps creating an open-work pattern. The Salish could quickly construct baskets of this type from native grasses and often used them to carry clams or other foods.

17
LARGE STORAGE BASKET
See p. 22

NOOTKA-MAKAH

18
SMALL LIDDED
OVAL-SHAPED BASKET
4¼" x 2⅞" oval, 1⅞" high. Very finely woven basket has 20 stitches per inch and employs the wrapped S-twining technique. The warp is twisted cedar bark; the weft is very finely shredded bear grass. The ornamentation is in three bands of black with a zigzag variation of natural color in the center band. This basket illustrates beautiful workmanship.

19
SMALL KNOB LIDDED
STORAGE BASKET
3¼" diameter, 2¾" high with lid. In this wrapped S-twined basket woven with ten stitches per inch, cedar bark forms the warp; the weft is grass which can be easily dyed. The design of the base is simple with gold and burgundy bands; a burgundy knob ending in two whirls tops the lid.

20
SMALL LIDDED BASKET
2⅞" diameter, 2" high. Small basket is in wrapped S-twining technique with decorations in red, yellow, green, and purple dyed split grasses. The whale is a popular motif among the Nootka-Makah.

21
SMALL LIDDED BASKET
3" diameter, 2" high. Finely woven small basket construction is of cedar bark and split grasses in wrapped S-twining technique. Another popular motif of the Nootka-Makah, the bird design consists of blue and red dyed grasses.

The Nootka occupy the central western length of Vancouver Island, British Columbia, and the Makah reside on the adjacent mainland to the south in the northwest portion of Washington state. The most easily recognized characteristic of their basketry is the predominance of the wrapped S-twining technique. A single weft stays on the interior surface while the second element passes around the warp and "rigid" weft. Split grasses which are colored for decoration with vivid aniline dyes that tend to fade with age make up the moving weft. Thin pieces of cedar are the warps.

The construction of Nootka-Makah baskets can and does involve other weaves, especially in the start. A popular method of starting is by plaiting and then having several rows of plain, 2 element S-twining to the edge of the flat bottom; there the wrapped twining begins forming the body of the basket. When warps cross in a radial position at the start, the initial weave may be plain, 3 element S-twining for strength followed by plain, 2 element S-twining to complete the bottom. The body portion of some baskets may alternate rows of plaiting and twining. To finish the upper portion of lidded baskets, alternate warps extend up to hold a strip of cedar bark inserted by plaiting.

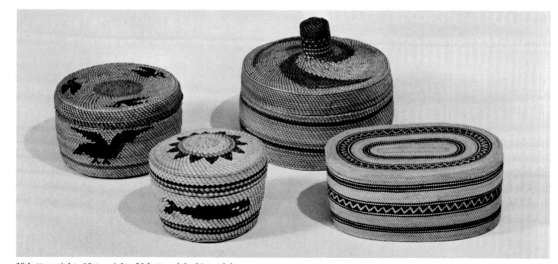

18 bottom right, 19 top right, 20 bottom left, 21 top left

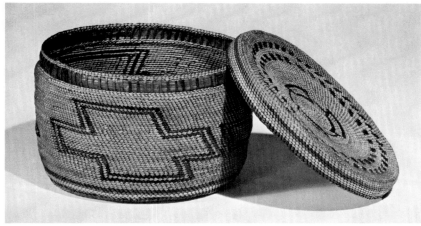

22

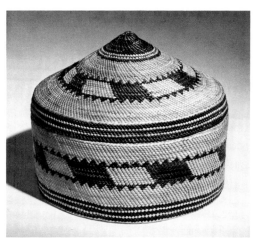

23

24

22
LIDDED STORAGE BASKET
6½" diameter, 4¼" high. Starting with a plaited weave on the bottom, this basket is woven in the wrapped S-twining technique with cedar bark warp and grass weft. The ornamentation consists of a modified maltese cross design executed in black with bands of brown and yellow dyed grass at the bottom of the basket and around the lid rim. The lid also has an interesting black design.

23
CONICAL LIDDED
STORAGE BASKET
5½" diameter, 5½" high. The conical form of this basket lid is an interesting variant from the more common flat examples. The technique is wrapped S-twining with a plaited bottom start. Aniline dyes colored the grasses in the designs; these dyes have faded, especially on the lid. A bluish-green band with triangular edges encloses the yellow parallelogram design. The bottom of the basket and lid have double weft rows forming a purple line enclosed above and below by a double weft row of blue-green lines.

24
SQUARE STORAGE BASKET
5½" square, 3½" high. Starting with a plain plaited bottom of cedar bark, the same technique is used up the sides with alternate rows of plain, 2 element S-twining. This is an interesting example of the two different weaves.

25
FOUR BASKETRY ENCASED BOTTLES
See p. 23

26
TWO BASKETRY COVERED JARS
See p. 24

WASCO, NEZ PERCE

The Wasco and Nez Perce are two distinct groups which are separated geographically, the former in the northwest portion of Oregon along the Columbia River and the latter in the northeastern section of Oregon and extending into the adjoining states. However, both weave bags by plain, 2 element Z-twining, utilizing twisted Indian hemp for warps and wefts. Both have dyed corn husk or grass for decoration, and the Nez Perce also may add wool yarn. The Nez Perce work the design motifs into the bags by false embroidery, and the Wasco by wrapped twining. The interiors of the baskets are roughly finished due to uneven cutting of the weft ends.

 The Nez Perce bags are usually flat and rectangular; those of the Wasco are circular and open. When handles occur on Wasco baskets, they consist of braided fibers; those of the Nez Perce are simply strips of leather or just a cordage drawstring. The Wasco may sew a leather strip over the rim of their bags.

27
FLEXIBLE STORAGE BASKET OR BAG
6″ diameter, 4½″ high. This basket weave is in plain, 2 element Z-twined technique with wrapped Z-twining for decoration. The weaver used commercial cord for the point of beginning and native Indian hemp for the remainder. A buckskin strip with scalloped edges reinforces the rim. Five white trade beads sewn into each of the projections add decoration. Wasco.

28
FLEXIBLE BASKET OR
BAG WITH HANDLE
5½″ diameter, 5″ high. A plain, 2 element Z-twined basket of native Indian hemp has wrapped Z-twining for decoration. The design depicts one horse with rider, one other horse, and eight human figures. The braided handle has a leather reinforcement sewn on at the center. Wasco.

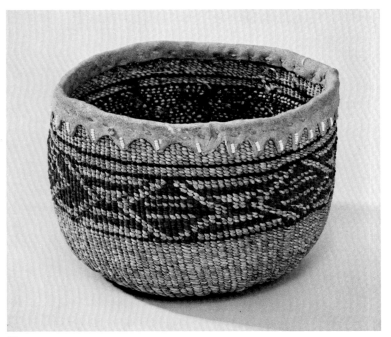

27

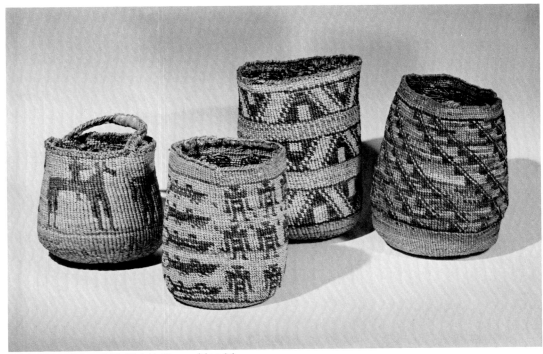

28 *left,* 29 *second from right,* 30 *right,* 31 *second from left*

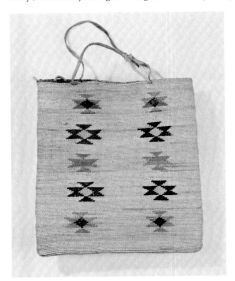

32

29
CYLINDRICAL FLEXIBLE BASKET
5" diameter, 7¼" high. Basket weave is plain, 2 element Z-twining with wrapped Z-twining technique for decoration. The square and triangle designs of this basket are a common motif in Wasco basketry since they adapt well to the technique of wrapped Z-twining decoration. Wasco.

30
TALL FLEXIBLE BASKET OR BAG
5½" diameter, 7" high. Diagonal bands of triangular designs repeat around this basket. The weave is in plain, 2 element Z-twined technique with wrapped Z-twining for decoration. The Indian hemp used in Wasco baskets resembles a strong twine; the baskets could withstand heavy use. Wasco.

31
CYLINDRICAL FLEXIBLE BASKET
4¼" diameter, 6" high. This example of a type of basket often called a "Sally Bag" utilizes the usual Wasco technique: plain, 2 element Z-twined with wrapped Z-twining for decoration. The decoration depicts human figures and fish (?) forms. Wasco.

32
RECTANGULAR BAG WITH
LEATHER STRAP HANDLE
7½" wide, 8" high. A small bag used for personal items utilizes twisted cordage warp of Indian hemp in plain, 2 element Z-twined technique. False embroidery in corn husk and yarn dyed red, blue, green, yellow, brown, and orange provides the designs—a stylized star motif on one side and a single flower plant motif on the other. Nez Perce.

SILETZ

Siletz has come to be a catchall term to refer to the basketry of Oregon Indians. The word comes from the name of a relatively small coastal tribe whose territory became the "reservation" for remnants of other Oregon groups sent there in 1855 when they were dispossessed of their homelands following the Indian wars in Oregon.

There is a tendency for the basketry to reflect European influences with such things as ornamental vase forms and long, braided carrying handles. The weave of this type of basket is plain, 2 element S-twined, either close or open; when the weave is open, there is a tendency to have crossed warps.

33
STORAGE BASKET
7¼" diameter, 5¾" high. This sturdy basket of peeled hazel is woven in plain, 2 element S-twined technique. Hazelnut shoots are preferable to willow and other materials because of their ease in preparation for weaving and their immunity to insect pests. The warps are exposed and cross near the top to give a decorative effect. Braiding finishes the rim.

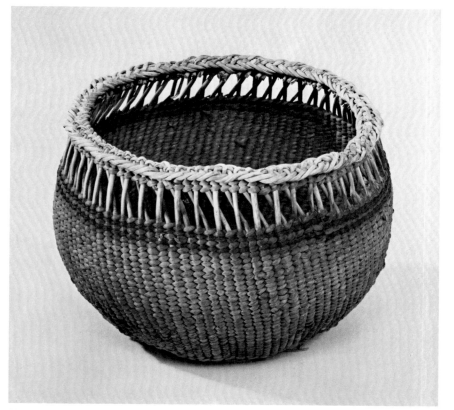

33

KLAMATH-MODOC

The Klamath of south central Oregon and the adjoining Modoc of northeastern California are related groups and have a common basketry tradition. They share the same weave of plain, 2 element Z-twining on twisted warps with overlay and wrapped twining decoration. Made of tule, which grows profusely in the marshy lands they occupied, the baskets are rather flexible and tend to have a roughened interior. The irregularly cutoff weft ends that protrude well above the surface cause this roughened interior.

34
BOWL-SHAPED BASKET
9" diameter, 3½" high. Basket construction is in typical Klamath-Modoc weaving technique of plain, 2 element Z-twining on twisted warps with overlay and wrapped twining decoration. Brown triangle and step-line pattern decorate the basket.

35
BOWL-SHAPED BASKET
7¾" diameter, 3⅞" high. Basket weave is in plain, 2 element Z-twining with an interesting stepped pattern woven in wrapped twining technique with tule dyed brown.

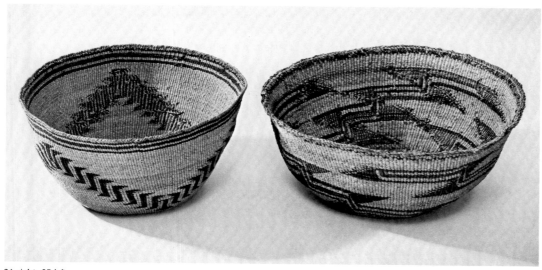

34 *right*, 35 *left*

36

BOWL-SHAPED BASKET

8¼" diameter, 4" high. This plain, 2 element Z-twined basket has decoration in a triangular motif with yellow dyed porcupine quills added for variation. Boiling quills in wolf moss dyes them yellow. The interior shows the rough finish left when the weft ends are irregularly cut. Some overlay twining is evident and two bands of plain, 3 element Z-twining near the top give the basket added strength.

37

SMALL STORAGE BASKET

7" diameter, 4¼" high. Basket weave is in plain, 2 element Z-twining with overlay twining over all. The design in tule, dyed black by burying the wefts in mud springs for a period up to six months, is a series of stepped parallelograms with double-pointed arrows interspersed around the basket.

38

BASKET IN FORM OF HANDLED CUP

5" diameter, 2¾" high. This basket is an example of novelty baskets in the form of articles of European derivation made for commercial purposes. It is in plain, 2 element Z-twined technique with cordage warps.

39

ARROW QUIVER

17" long. This flat conical basket is for carrying arrows. Woven in plain, 2 element Z-twining on twisted warps, the basket has solid alternate lines of brown dyed tule encircling the basket at intervals for decoration. This quiver illustrates the vast extent to which the Klamath and Modoc used tules and bulrushes in the manufacture of most of their possessions. Whereas other tribes might have made such things as the quiver, moccasins, leggings, and even house coverings out of skins, these people preferred to weave such articles out of the plants growing in marshy areas.

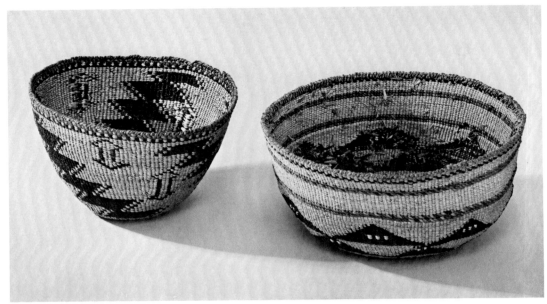

36 right, 37 left

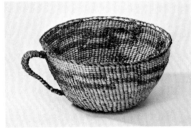

38

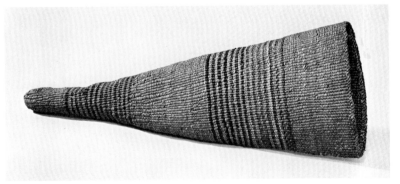

39

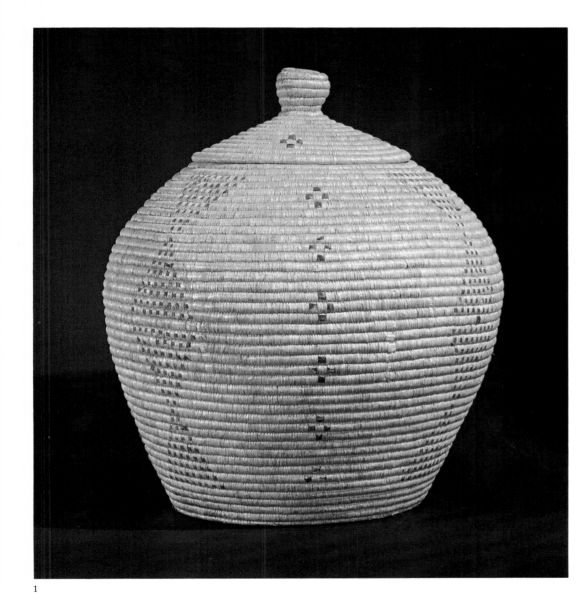

1

1
TALL LIDDED STORAGE BASKET
16½″ diameter, 18½″ high. Coiled construc-
tion utilizes natural grasses. There is an
imbricated geometric design in strips of skin
from seal and a large reptile. Since reptiles
are rare and small in this area, such skin may
have been a trade item.

3
LARGE STORAGE BASKET
WITH KNOBBED LID
10¾″ diameter, 9¼″ high. Cylindrical basket
made of finely shredded beach grasses has a
plain, 2 element Z-twined weave, producing
a warp face, linenlike finish. Red, white,
green, pink, purple, and blue-green yarn in
the false embroidery technique is the basket
decoration.

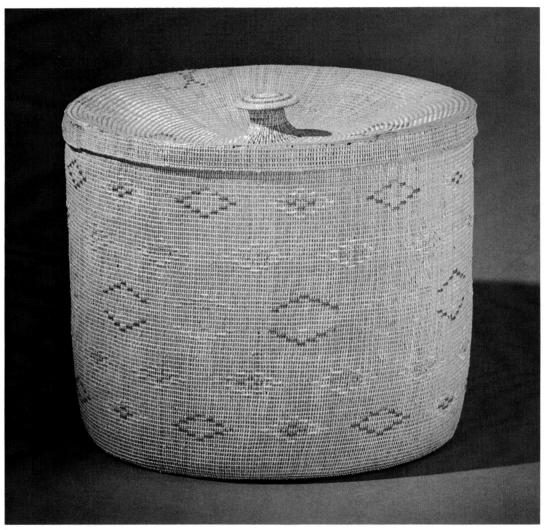

3

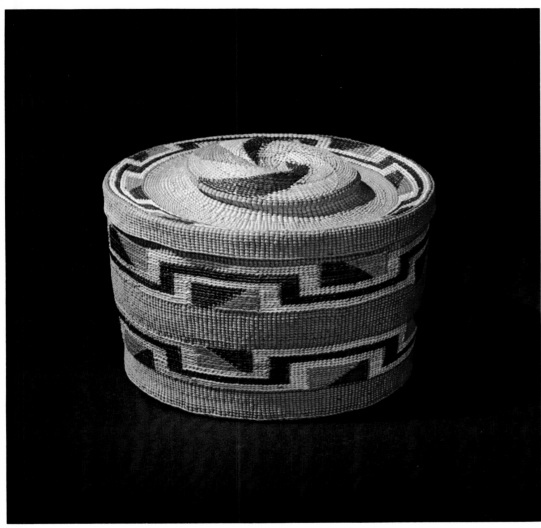

4
STORAGE BASKET WITH
LIDDED "RATTLE TOP"
7½" diameter, 5" high. This interesting example of Tlingit basketry has a plain, 2 element Z-twined weave with false embroidery decoration in yellow and orange dyed grasses. The weaver probably used commercial dye, but could have achieved yellow by steeping the grasses in a solution made from moss grass. Basic materials are spruce root and maidenhair fern stems.

On the outer edge of the lid and in the body of the basket, the design is a combination of the "wave" pattern shown by the continuous angular meandering line in brown and the "brown bear footprint" motif indicated by the rectangle divided into sections in brown and orange. Both designs exist in baskets woven during the mid 1800's and continue to be popular. The lid's center has a swirl design known as "fern frond," which is indicative of the young fern leaves as they uncurl in the spring. One popular feature or trademark of the Tlingits is the "rattle top"; in space formed in the lid, the weaver placed seeds, pebbles, or shot which rattle when shaken.

10
LIDDED JAR-SHAPED BASKET
4½" diameter, 6¼" high including lid. Basket weave is made with spruce root in plain, 2 element Z-twining with false embroidery decoration in red and yellow. The pattern is "shaman's hat," literally "spirit around the head." Weavers adapt this commonly used pattern to all forms and sizes of baskets.

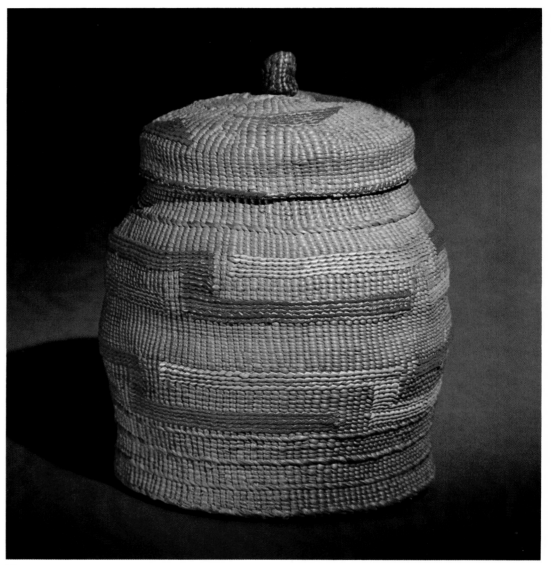

10

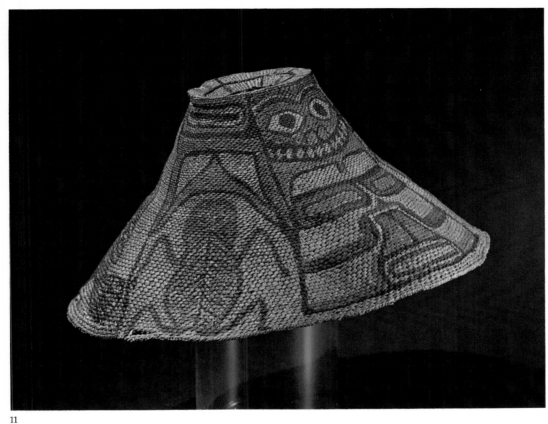

11

11
CEREMONIAL HAT
12″ diameter, 9″ high. The weave is twill, 2 element S-twined with plain, 2 element S-twining used in a rounded "cap" form woven under the crown to fit the head. The painted-on designs represent mythological beings or totems in the form of a puffin bird, frog, and killer whale. The basket originated prior to 1900.

17
LARGE STORAGE BASKET
19¼" long, 17¼" wide, oval, 12½" high.
Coiled cedar basket has imbricated decoration in cherry bark and straw. The decorative elements comprised of triangles in vertical rows are called "arrowheads touching bases." It is said that this basket belonged to Angeline, daughter of Chief Seattle, after whom the city in the state of Washington is named.

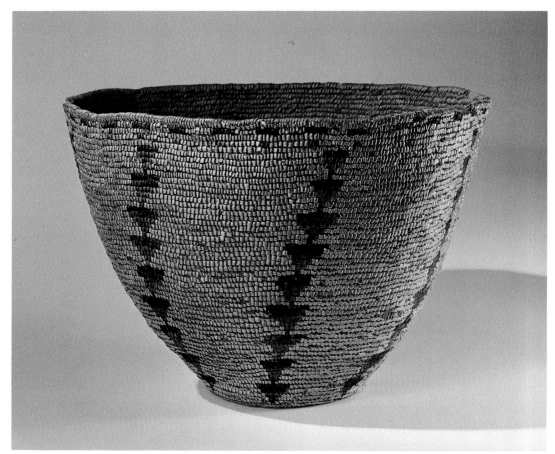

17

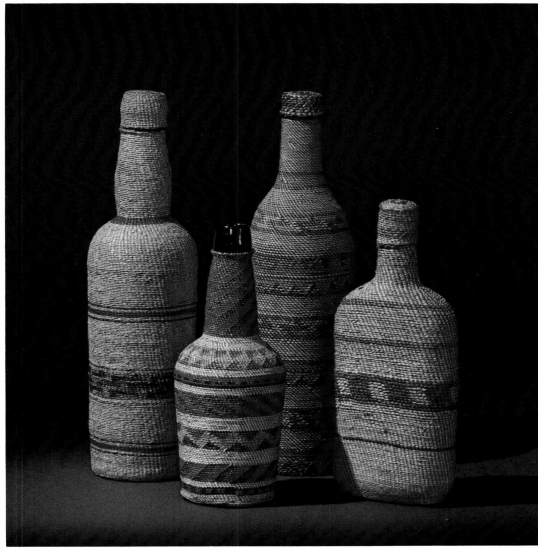

25

25
FOUR BASKETRY ENCASED BOTTLES
2⅞"–3½" diameter, 8½"–12½" high, one flask-shaped 3⅛" long base, 1½" wide base. These bottles covered with basketry are an example of the acculturation and adaptation of the Indian art. Since their first contact with civilization, Indians have treasured bottles. The technique is wrapped S-twining. Grasses dyed in a wide selection of colors form geometric patterns on the variously shaped bottles.

26
TWO BASKETRY COVERED JARS
5"–5¾" diameter, 4¼"–5¼" high. In this example of acculturation, Chinese brown-glazed ceramic vessels covered in wrapped S-twining technique have decoration of dyed grasses in burgundy, blue, green, brown, pink, and orange. The delicate flower motifs reflect European influence. It is possible to cover in basketry almost any ceramic form, and the Nootka-Makah have shown great ingenuity and skill in covering these objects.

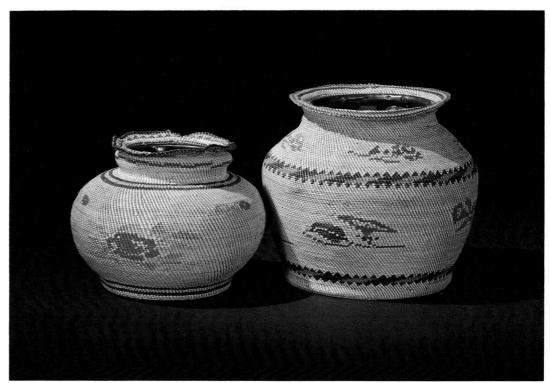

26

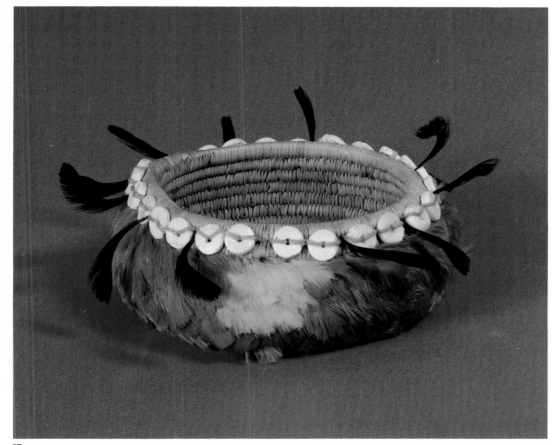

57

57
COILED FEATHER BASKET
3¾" diameter, 1½" high. This completely feathered ceremonial basket was not for utility use. Coiled basket has approximately 20 stitches per inch. The maker wove brown, orange, and yellow feathers with a touch of bright blue on the bottom into the coil. Cordage holds clam shell disc beads in place around the rim. Quail top knot feathers further decorate the basket.

58
COILED FEATHER BASKET
4¼″ diameter, 2″ high. This basket has
alternate rows of yellow and brown irides-
cent feathers from hummingbirds and quail
top knots woven into the coils. Early collec-
tors called this type "jewel" basket.

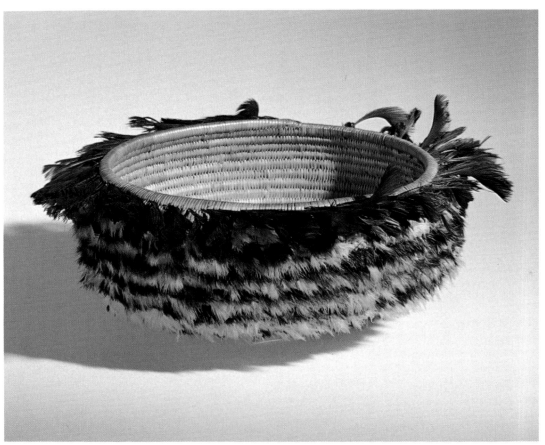

58

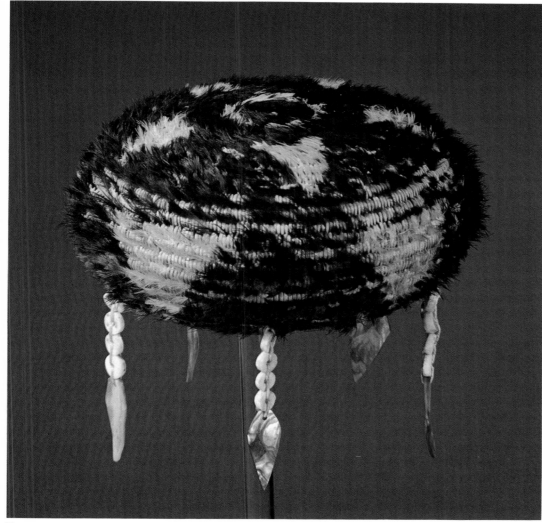

59
COILED FEATHER BASKET
3¾" diameter, 2¼" high. Coiled basket has yellow and brown iridescent hummingbird feathers woven in to form a geometric pattern. Clam shell disc beads and abalone pendants decorate the basket. These baskets tend to be rare since weaving in the feathers was difficult and time-consuming and some feathers were hard to obtain.

60
BEADED GIFT BASKET
5½″ diameter, 3¾″ high. Basket weave is plain, 2 element Z-twining with overlay stitches in alternating bands visible on the inside. Decoration is yellow, blue, and white trade beads in geometric designs. The maker added the beading on with a cloth backing rather than weaving it into the twined stitches.

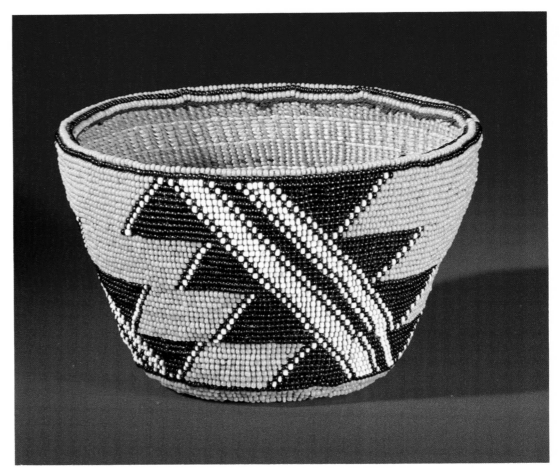

60

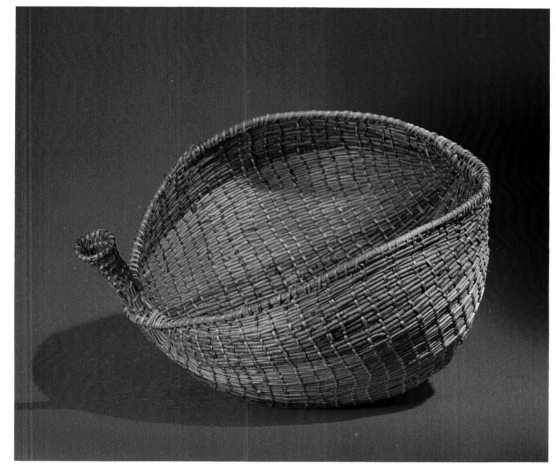

74

74
SEED BEATER
12″ long, 11½″ wide, 7¾″ high. Twilled
willow basket has 2 element S-twining. The
Paiute gathered seeds by whipping the grass
with a seed beater to dislodge them and
catching them in a conical burden basket for
transport to camp sites. The handle and deep
dimensions make this an extremely effective
working tool and a handsome basket.

84
SHALLOW BOWL-SHAPED BASKET
18¾" diameter, 4" high. Large clockwise coiled bowl shows effective use of the mottled brown coloring of the juncus. The stem of the juncus usually has two colors, straw and brown. The Mission Indians often dyed juncus black by burying it in available mud. The striking design of this basket consists of an interesting butterfly motif surrounding a central four-petaled flower.

85
LARGE STORAGE BASKET
17½" diameter, 5¼" high. Coiled basket has a five-pointed flower petal woven in variously colored juncus on the bottom with triangular designs continuing up the flared sides.

86
STORAGE BASKET
8½" diameter, 2⅛" high. Finely stitched coiled basket is of mottled tan and brown juncus. The well sorted out colors show a subtle design, including a rooster form on the flared side. A five-pointed star is emphasized in the center. The outline of the star illustrates the special method of ending stitches common in Mission basketry.

87
STORAGE BASKET
11" diameter, 3" high. This basket decoration has a four-petaled flower design with a triangle motif between the petals. The effective use of the colored materials of juncus and devil's claw create a distinctive pattern.

88
SHALLOW STORAGE BASKET
8¼" diameter, 2¾" high. Coiled basket is in varying shades of juncus. The main design is an eagle with outstretched wings. The Mission Indians seldom patterned early baskets; they used only variously colored encircling bands for variation. Later they made baskets with animal, star, and other designs to satisfy commercial demands.

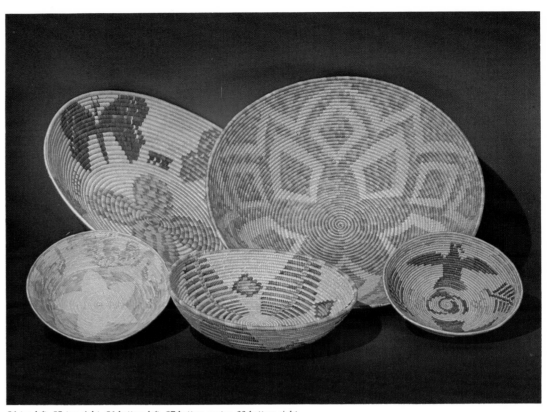

84 *top left*, 85 *top right*, 86 *bottom left*, 87 *bottom center*, 88 *bottom right*

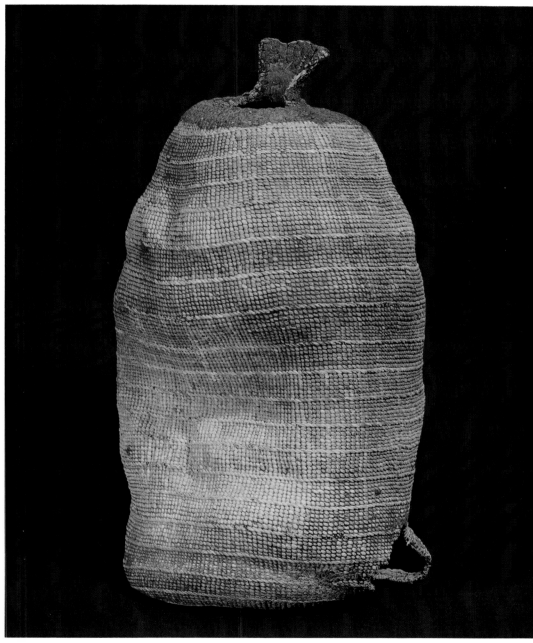

94

94
TWINED WATER BOTTLE
11¼" x 9½" diameter, 18¼" high. To make it waterproof, asphalt coats this plain, 2 element Z-twined basket, strengthened at intervals with 3 element Z-twining. This basket, found in the Cuyama Valley area of Santa Barbara County, California, is typical of the region. It comprises a special type of water bottle described by Mohr and Sample in 1955. It is thought that this bottle was "ritually killed" with a hole cut at the bottom edge and at the neck rendering it useless. Chumash.

124
CYLINDRICAL BASKET
10¼″ diameter, 8¾″ high. Bear grass founda-
tion has stitching with yucca and devil's
claw. An angular motif of stepped triangles
provides simple decoration.

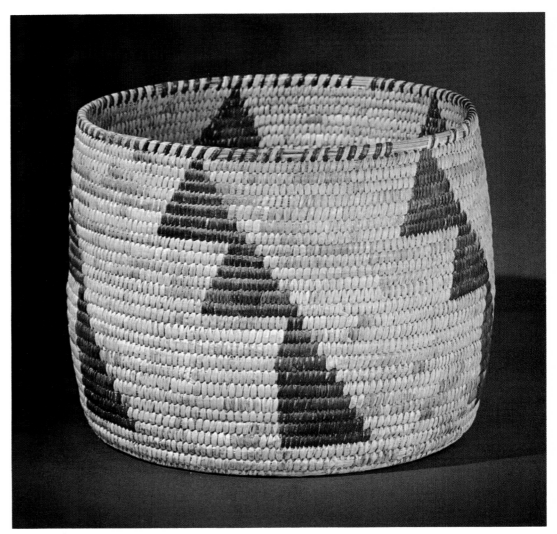

124

SHASTA

Shasta is a convenient term to identify basketry from north central California territory occupied by the Shasta and their neighbors, such as the Achomawi, Atsugewi, Yana, and northern Wintun. The weave of Shastan baskets follows the technique of the tribes to the west with plain, 2 element S-twining and overlay technique in decoration wherein the design occurs on both the inside and outside of the basket. A half twist of the overlay on the weft makes this overlay. Though well done, Shastan basketry tends to be somewhat coarser than examples to the west. On occasion, the rim of the basket may have a wooden rod or splint coiled around it. Meandering band designs with pendant triangles are also a popular feature.

40

40
CONICAL STORAGE BASKET
12½" maximum diameter, 8⅛" high. This fine example of Shastan basketry has a flat bottom in 3 element S-twining and sides in plain, 2 element S-twining with overlay. The geometric design of triangles and meandering bands woven of dyed bear grass is visible on the inside as well as outside. The weaver dyes white bear grass brown in an extract from alder bark. One wrapped and one exposed reinforcing rod finish the rim. This basket originated circa 1900.

YUROK, KAROK, HUPA

The Yurok, Karok, and Hupa, who were prolific basket makers, lived in northwestern California; the Hupas were concentrated in the Hupa Valley of Humboldt County. Because the basketry of these tribes is quite similar in materials and technique, it is virtually impossible to determine the tribal origin of a particular basket unless its specific history is known.

For warps, hazelnut shoots were preferable to willow or other materials because of their ease in preparation for weaving and their immunity to insect pests. In addition, in the 1800's and presumably earlier, basket makers avoided willow because of the belief that it belonged to the underworld since it grew along rivers. Where fires had burned over the thickets, the weavers gathered hazelnut shoots as soon as the sap was flowing and leaves had begun to sprout. They peeled the twigs while still fresh.

Except for "stick baskets" where weft and warp are of the same material, tree roots composed the wefts. The basket makers first prepared all these roots by an involved "baking" process and then split them. When extra strength was desired, they used roots of deciduous trees, such as alder, willow, and cottonwood; and when baskets were to be watertight, they sought the roots of coniferous trees, principally pine. For decoration, bear grass provided white coloring and maidenhair fern provided black.

The weave is plain, 2 element S-twining for the body of the basket with 3 element twining in the first half inch to one inch of the start and then perhaps a double row of 3 element twining three-quarters of an inch to an inch or so beyond that. Decoration by overlay technique with a half twist or without a twist involves the use of grass, maidenhair fern stems, and dyed porcupine quills. When there is not a half twist overlay, the design shows only on the outer, work surface of the basket.

The weavers took great care while weaving to keep the materials damp; otherwise, the basket would have bulges caused by uneven contractions in the course of drying. On windy days, fine work was virtually impossible because the materials dried too rapidly.

41
COOKING BASKET
14¼" diameter, 6¾" high. This basket weave is plain, 2 element S-twined with plain, 3 element S-twining extending two inches out from the start. The overlay design in bear grass is in the "it encircles" pattern. As a result of use, there is residue in the basket. A closely woven basket could serve for liquids and cooking as the fibers would swell with moisture and become water tight. Heated stones placed in the basket would cook food.

42
LARGE STORAGE BASKET
18" x 17" diameter, 13" high. Basket is woven in the typical Yurok-Karok-Hupa technique: plain, 2 element S-twining with plain, 3 element S-twining at start and three inches out from the center. Also, there are 3 elements at the edge of the bottom portion for one row and at the rim for two rows. The interesting stepped geometric decoration in overlay, which shows only on the outside, is a variation of a design entitled "waxpoo." Its meaning is uncertain, but there appears to be a reference to "the middle." There is a wrapped rod at the rim for reinforcement.

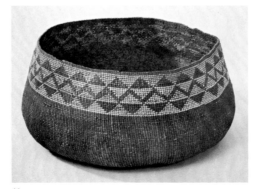

41

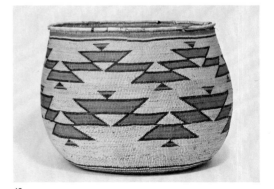

42

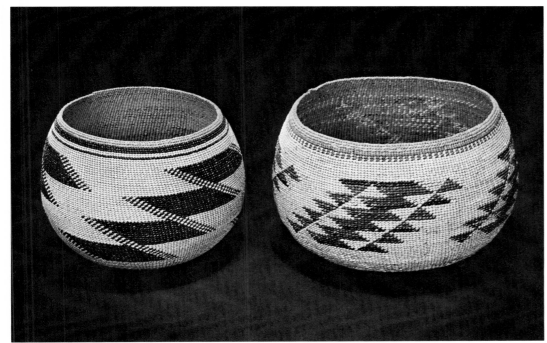

43 *right,* 44 *left*

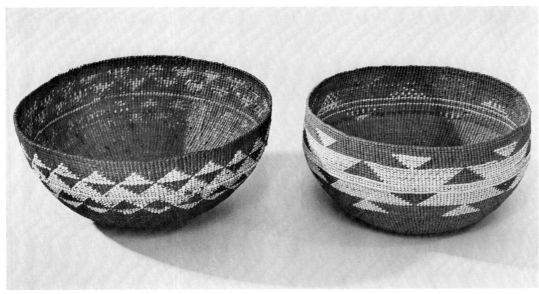

45 *left,* 46 *right*

43
STORAGE BASKET
7³⁄₈" diameter, 4½" high. Basket weave is in plain, 2 element S-twined technique with plain, 3 element S-twining at start and two rows of twill, 2 element S-twining. The overlay decoration, most of which does not show on the inside, is an effective layout of triangles and parallelograms called the "ladder design." The design may be a representation of the ladder created when steps were cut into a log to make a ladder which leads into the pit of the house.

44
STORAGE BASKET
6" diameter, 4½" high. Maidenhair fern stems form the black geometric design in overlay. The oblique-angled parallelograms form a design called "one rest on the other." The basket is in plain, 2 element S-twined technique with plain, 3 element S-twining at start and at edge of bottom portion. With age, the swamp grass fibers in these baskets acquire an attractive golden-brown patina.

45
COOKING BASKET
8" diameter, 3½" high. Basket weave is in plain, 2 element S-twined technique with plain, 3 element S-twining at the start followed by twill, 2 element S-twining. The design is a combination of triangles in overlay decoration in the "it encircles" pattern. A row of wrapped twining introduced in the body of the basket forms a raised surface about 1¼ inches from the rim.

46
COOKING BASKET
6¾" diameter, 3½" high. Weave is plain, 2 element S-twining with 3 element S-twining at the start for ¾ inch; 1¾ inch from the start is a single row of 3 element S-twining. The overlay decoration in white bear grass is the characteristic "waxpoo" design. Two rows of wrapped twining appear 1¼ inch from the rim; this is a customary strengthening technique for cooking baskets.

47
COOKING BASKET
6½" diameter, 4" high. After a plain, 3 element S-twined start for ½ inch, this basket construction is in plain, 2 element S-twining with overlay decoration. A row of wrapped twining appears about 2 inches from the start and again ½ inch below the rim. The pointed circular motif following the start is called "sharp tooth" design. The central decoration of stepped lines and parallelograms is the "long worm." Around the rim is a variation of the "flint design." The weaver often obtained the red-brown color of the pine root weft by soaking the pine root in a solution made from red alder root.

48
BASKETRY CAP
7" diameter, 3½" high. As the hats from the Yurok-Karok-Hupa group demonstrate, basketry is a versatile art extending even into wearing apparel. Nearly all of the women wore finely twined hats. The weaving technique of plain, 2 element S-twining with plain, 3 element S-twining at the start is common for hats and cooking bowls; materials used in both were also the same. The "foot" design appears on the top of this hat; the vertical stepped rectangles are a variant of the "flint" design. The flint depicted here is not the material commonly known by that name; instead it refers to obsidian from which the tribes made long ceremonial knives and stone tools.

49
BASKETRY CAP
7" diameter, 3" high. Overlay decoration completely covers hat woven in plain, 2 element S-twining with plain, 3 element S-twining at start. The geometric designs and bands of maidenhair fern stems include the "sharp tooth" motif on top, another aspect of the "waxpoo" design around the central band, and a variation of the "flint" design at intervals below the rim. The maidenhair fern stems are a natural, glossy black color.

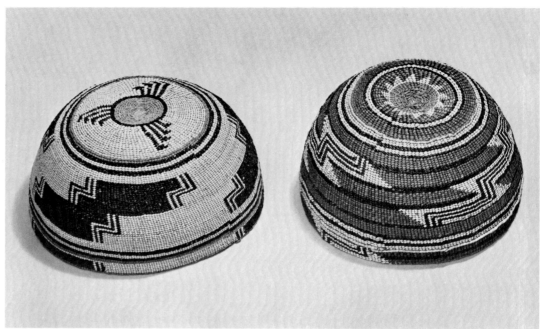

47 right, 48 left

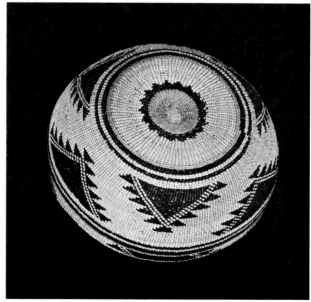

49

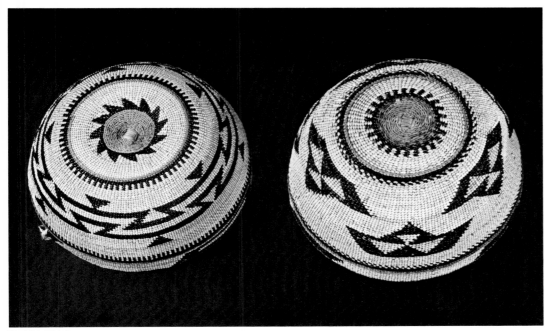

50 *right*, 51 *left*

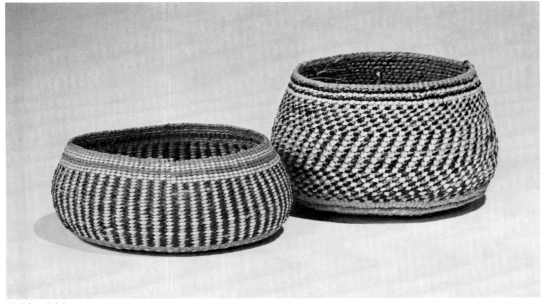

52 *right*, 53 *left*

50
BASKETRY CAP
7" diameter, 3 1/2" high. The designs depicted in maidenhair fern and yellow dyed bear grass are "sitting," a common motif of oblique isosceles triangles; the yellow triangles are "nose of snake"; a variant of the "flint" design appears around the rim. Weave is plain, 2 element S-twined, started with weft rows of plain, 3 element S-twining for reinforcement 1 1/2 inches out from the start and 1/2 inch from edge of rim.

51
BASKETRY CAP
6 1/2" diameter, 2 3/4" high. From a plain, 3 element S-twining start, the remaining weave is plain, 2 element S-twining with overlay decoration. This angular characteristic "waxpoo" design is formed by maidenhair fern stems. On top is the "sharp tooth" design, and around the rim appears a variant of the "flint" design.

52
SMALL STORAGE BASKET
4 1/2" diameter, 2 3/4" high. This is an unusual basket as its construction is in a twill weave which is found more often in large work baskets of the Yurok-Karok-Hupa group. As shown by the uncut weft endings in the interior, it is unfinished. The start is plain, 3 element S-twining for 1/2 inch, followed by plain, 2 element S-twining with overlay decoration for 1 1/2 inches. Next is one row of wrapped twining, then three rows of plain, 2 element S-twining, after which the remainder is in twill, 2 element S-twining. Alternating use of maidenhair fern stems and bear grass forms the motif.

53
SMALL STORAGE BASKET
4 1/2" diameter, 1 3/4" high. Weave is plain, 2 element S-twining with overlay decoration. The alternate use of maidenhair fern stem and bear grass forms the vertical striped pattern.

54

BABY CRADLE

24" long, 12" wide. Slipper-shaped open-work basket is of hazelnut shoots. At the upper end, two rows of alternate S-twining and Z-twining hold the small twigs in place ⅛ inch apart. Five rows of alternating plain, 2 element S-twining and Z-twining follow. The alternating groups of three weft rows continue at intervals down the length of the basket. The twigs constituting the bottom of the slipper-shaped basket continue to the end of the square toe and are fastened off, while those that form the sides are ingeniously bent and woven in twined technique to form the toe of the slipper shape.

At birth, the Indians placed a baby in the cradle board. Leather straps held the baby firmly and safely in place. Twigs inserted at the bottom formed a foot rest used when the baby was small. Later, they strapped the child in place in a sitting position with the feet hanging over the edge of the slipper-shaped cradle. When traveling, the mother strapped the cradle to her back; when at home, she usually fastened it to a nearby tree where the baby could watch the surrounding activities.

With this type of cradle board, they usually used a separate conical-peaked sun shield.

55

OPEN-WORK GATHERING BASKET

15½" diameter, 14¼" high. Basket construction is of hazelnut shoots in plain, 2 element S-twining with crossed warps just below the rim. There is an interesting gray-colored plant stem decoration of zigzag line inserted into the wefts.

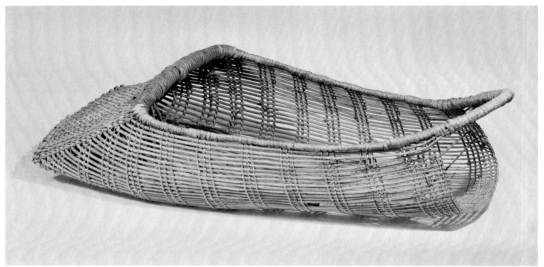

54

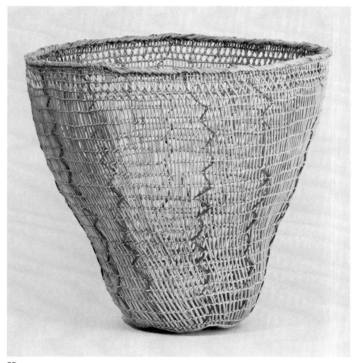

55

POMO

The Pomo of California now center around Clear Lake, but their lands formerly stretched to the ocean, some 100 miles north of San Francisco. Some consider them to be among the finest, if not the finest, basket makers in the world. They know the three basic techniques of plaiting, twining, and coiling, but they restrict the former to the manufacture of the handled seed beater. The Pomo excel in twining and coiling and produce basketry of consistent good quality with even stitches. There are a variety of characteristic weaves, forms, designs, and decorations which make Pomo basketry especially distinctive from those of other tribes.

In twining, the Pomo use plain and twill techniques. The lean of the stitch can be either up to the right (S) or down to the right (Z) depending on the type of basket being woven. The Pomo use two weft elements most often in twining, but also use three elements. With three elements, the weave can be plain or braided or combined to form lattice twining. In lattice twining, one weft element stays to one side of the warps and the two other wefts wrap around the third weft and warps. Willow predominates as the material for warps, and the roots of such plants as the carex, sedge, and pine predominate for wefts.

In coiling, the willow shoot foundation may be a single rod or in a three-rod triangular position. The root stitches enclosing the coils are usually narrow and even. Baskets with 18 stitches per inch of coil are common; 42–53 stitches per inch are the finest weave. Coiled basketry has not only elaborately woven patterns, but also may have much decoration of feathers and/or shell beads and pendants. One trademark of the Pomo weaver's art is the basket that is completely covered with feathers in colorful designs.

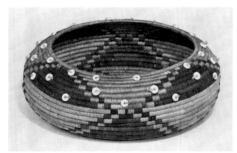

56

56
"TREASURE" BASKET WITH
CLAM SHELL BEADS
6½" diameter, 2¼" high. Coiled basket has geometric design in redbud with approximately 24 stitches per inch. The clam shell disc beads had a monetary value to the Pomo similar to the "wampum" of the Indians of the Northeastern United States; thus, the weaver decorated this basket with some of her wealth. The basket dates circa 1910.

57
COILED FEATHER BASKET
See p. 25

58
COILED FEATHER BASKET
See p. 26

59
COILED FEATHER BASKET
See p. 27

60
BEADED GIFT BASKET
See p. 28

MAIDU

The Maidu of northeast central California are now perhaps best known for their coiled basketry, but they made both coiled and twined baskets and excelled in both techniques. With three willow rods as foundation, the favorite globular shape is formed with the encircling stitches of split willow and unpeeled redbud, the latter displaying the color of the design. One characteristic of Maidu coiled basketry is the consistent splitting of stitches on the interior, non-work surface of the basket.

61
LARGE BOWL-SHAPED
STORAGE BASKET
15½" diameter, 7½" high. Coiled basket of willow with split stitches showing on the interior, non-work surface illustrates this distinguishing technique of the Maidu. The decoration of this beautifully shaped, solid basket is in a favorite geometric design worked in unpeeled redbud; it may represent a variant of the "duck-wing" pattern. In the basket, there appears to be a residue, probably from storing grain or seeds.

62
STORAGE BASKET
11" diameter, 8" high. Basket construction utilizes redbud in twilled, 2 element S-twining technique. In this basket, using the peeled portion of the redbud for the lighter stitches creates the geometric design.

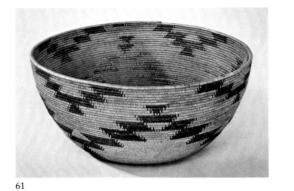

61

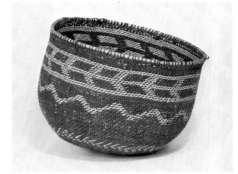

62

WASHO

Washo territory extended out around the shores of Lake Tahoe. These excellent weavers made many fine coiled baskets and were famous for the symmetry of their isolated decorative motifs and their uniform stitching perfection. The high point of fine weaving for the Washo is the exquisite work of Dat-So-La-Lee, whose efforts spanned the period of the early 1900's until her death in 1925. Also, the Washo wove twined basketry for gathering activities which is comparable in technique and form to their Paiute neighbors'.

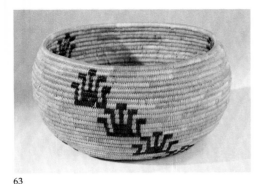

63

63
SMALL STORAGE BASKET
6⅛" diameter, 3¼" high. Finely coiled basket with 18–20 stitches per inch is in willow. Decoration is of black stem of bracken fern. All inside stitches are split. The quail top knot design is typical of the special, separate design motifs arranged in a particular pattern in Washo weaving. This is a good example of delicate design and symmetry of form in a type of basket which collectors often bought.

YOKUTS

The Yokuts occupied the southern portion of the great San Joaquin Valley of California. Their coiled basketry is easily recognizable, especially the wide, flat-shouldered baskets with bottle necks and the frequently used diamond band patterns, called, by some, a rattlesnake design.

The foundations of grasses or rushes have sewn around them stitches made principally from split willow or saw grass to produce the white background, bracken fern to give a black color, and redbud or the unpeeled root of tree yucca for showing red in the design. On occasion, the Yokuts added feathers, especially the quail top knot around the edge of the shoulders of necked jars.

64
NECKED JAR
9⅞" diameter, 5⅞" high. This coiled basket brings together several features typical of Yokuts baskets, such as the jar neck form with broad, flat shoulders and the use of the diamond or rattlesnake pattern alone or in combination with other elements. Usually the diamond is redbud, the light background is swamp grass, and the border is black fern. The insertion of quail top knot feathers around the edge of the shoulder was a feature of Yokuts baskets used in ceremonial or mortuary rites.

65
SMALL NECKED JAR
5⅛" diameter, 4¾" high. Coiled basket has an overall, swirl stepped pattern. Interspersed around the shoulder of the jar, alphabetical motifs are an example of Euro-American influence. The weaver could have made this for a particular person to use for trinkets and personal possessions.

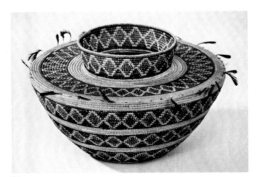

64

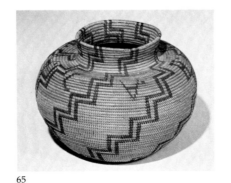

65

66
NECKED JAR
10¼" diameter, 6¼" high. This jar is a coiled flat-shouldered basket. The band patterns show an interesting use of human figures—alternating men and women holding hands are on the sides of the basket, and a band showing women only is on the top; these are sometimes called friendship figures. A row of crosses decorates the short cylindrical neck.

67
NECKED JAR
10½" diameter, 6¾" high. Coiled flat-shouldered basket has a simplified rattlesnake motif around the neck. The overall decoration is the popular swirl pattern using peeled willow, bracken fern, and redbud. The maker wove quail top knot feathers in around the edge of the shoulder.

68
BOWL-SHAPED BASKET
12" diameter, 5¾" high. Coiled flaring "dance" basket has a coarse weave. The design of human figures and geometric decorations of diamonds and pendant triangles are in alternating rows of black fern and redbud.

69
SHALLOW OVAL-SHAPED BASKET
16¼" long, 12¼" wide, 5" high. Interesting coiled, boat-shaped "dance" basket has variations of the rattlesnake pattern in bands at top and bottom. Between them are figures of men and women holding hands, possibly representing those participating in dance rituals. The use of human figures in Yokuts basketry dates prior to 1875. Designs are in alternating colors of redbud and black fern stem. Colors reverse in the two diamond patterns. The style of ticking on the rim may have come from neighboring tribes east of the Yokuts territory.

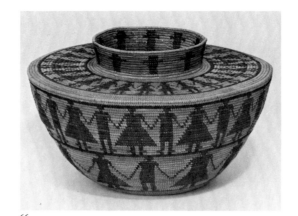
66

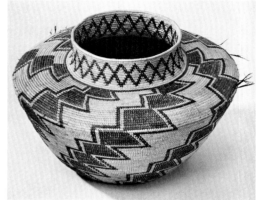
67

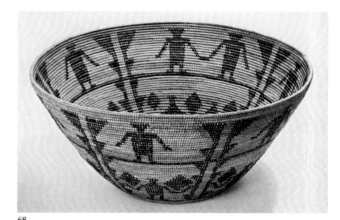
68

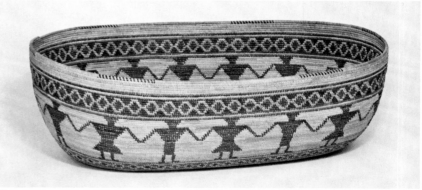
69

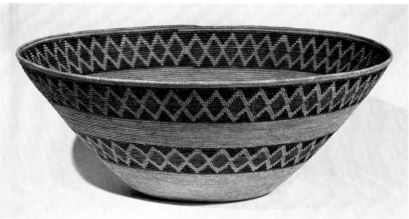

70

71

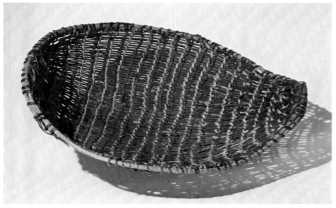

72

70
BOWL-SHAPED BASKET
20¼" diameter, 8" high. Large coiled basket shows good, typical use of the diamond, stylized rattlesnake motif. The designs in two wide bands are in typical colors: redbud diamonds are in a field of lighter colored swamp grass, and there is a border of black fern stem.

71
BOWL-SHAPED BASKET
12¼" diameter, 4¼" high. Coiled basket of swamp grass has decoration of redbud and black fern stem. The design is a modified rattlesnake pattern around the top and bottom with a row of swastika markings between them.

72
WINNOWING BASKET
13½" long, 11¾" wide, 4½" high. Twined basket uses twill, 2 element S-twined technique. The Yokuts used this basket in food gathering and processing activities, specifically to separate chaff from grain by tossing in a light breeze. Unpeeled whole redbud twigs form the warps; unpeeled redbud are the wefts, interspersed with willow for "color." The rim is of willow. This basket was obtained in Fresno County about 1905.

PAIUTE

73
BASKETRY CAP
8¼" diameter, 5¾" high. Cap woven of split willow is in twill, 2 element S-twining. The start of the basket and the last weft row at the rim are 3 element S-twined. The design, which consists of zigzag lines on the exterior and one zigzag line between rows of triangles on the interior, is worked in the outer, unpeeled shoots of willow. This is the typical shape and construction of the Paiute hat; compare this example with those of the Yurok-Karok-Hupa group. Women usually wore these hats; men also wore these hats when using a tumpline across the forehead to support a loaded burden basket.

74
SEED BEATER
See p. 29

75
CONICAL BURDEN BASKET
14¾" x 13¼" diameter, 15" high. Basket weave is of willow with redbud decoration in twill, 2 element S-twined technique with twill, 3 element S-twining at start and extending two inches out from center. The use of baskets for carrying heavy loads was a vital necessity for survival. This basket is the typical shape and weave of burden baskets, but most were much larger. The Paiute carried the loaded burden basket on the back by a tumpline which encircled the mid-portion of the basket and extended up over the forehead.

The Great Basin area of the United States was principally the home of the Paiute. Their basketry was vital to survival in the harsh, dry environment because they used baskets to gather wild plant food resources and to store these for lean periods. Also essential were effective, easily portable containers for water. The Paiute gathered wild seeds with the seed beater, harvested them into burden baskets, and processed them with the help of winnowers.

Twined basketry comprised the various utilitarian, light, sturdy woven items, while coiled basketry included small globular storage baskets. The Paiute used twill, 2 element S-twining as the principal weave and used both whole and split willow most often as the construction material.

Other groups in the Great Basin and in California made similar twined work baskets. The Paiute are also well known for their coiled beaded baskets.

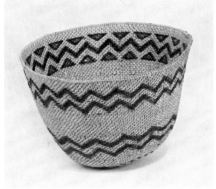

73

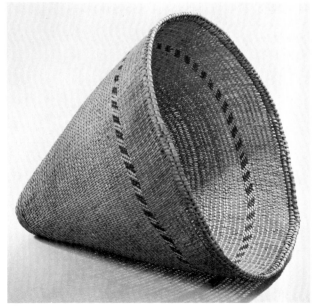

75

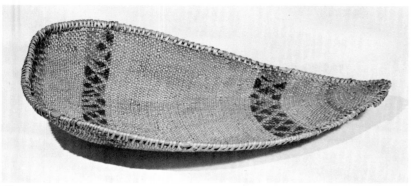

76

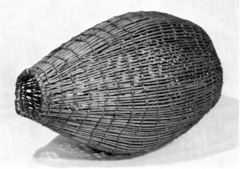

77

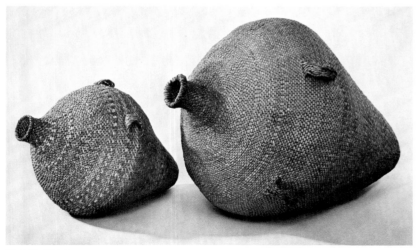

78 *right*, 79 *left*

76
WINNOWING TRAY
17½" long, 13½" wide. Twilled, 2 element S-twined weave is of willow with unpeeled outer portion of split twigs forming the simple diamond and triangle design. Wrapped sticks encircle the outer edge for strength. This triangular shape is typical of winnowing trays and is effective for tossing wild seeds to remove their outer coating.

77
UTILITY BASKET
10⅛" maximum diameter, 14" high. Basket construction is of whole willow twigs in plain, 2 element S-twining. In the upper half, there is a double warp. The Paiute may have used this basket to carry grasshoppers or crickets.

78
WATER BOTTLE
11¼" diameter, 16" high. Weave is of willow in twill, 2 element S-twining technique with twill, 3 element S-twining in the first three weft rows at the start. For carrying purposes, the Paiute added cordage handles. The conical form with the small-necked opening is the typical shape of the Paiute water container. The design illustrates an ingenious development in the construction of basketry and exhibits a highly specialized shape. Carrying and storing water in the arid regions of the Great Basin was a life and death necessity. The narrow neck prevented rapid evaporation; the contour is full for maximum capacity; and when the pointed end was placed in the sand, it prevented tipping.

79
WATER BOTTLE
7⅜" diameter, 11⅛" high. Small, willow water bottle is in twill, 2 element S-twined weave with twill, 3 element S-twining used at the start for six weft rows. Covering the water bottles inside and out with pinion gum made them durable and water tight.

80
CRADLE BOARD
29½" long, 14¾" wide. This Paiute baby
cradle constructed of willow twigs is typical.
The maker decoratively wrapped and tied the
cradle body in redbud. The hood and edges
are in plain and twill weave with 2 element
S-twining. The Paiute placed the baby on the
board and wrapped and tied him in place.
The mother carried the cradle on her back by
means of a strap over her forehead. In camp,
she placed the basket against the trunk of a
tree or hung it from a limb. The sun shield of
these cradles had decoration—a series of
parallel lines at an angle for a boy or a series of
zigzag lines for a girl. This one, for a boy, also
has decoration of strings of glass and ceramic
beads.

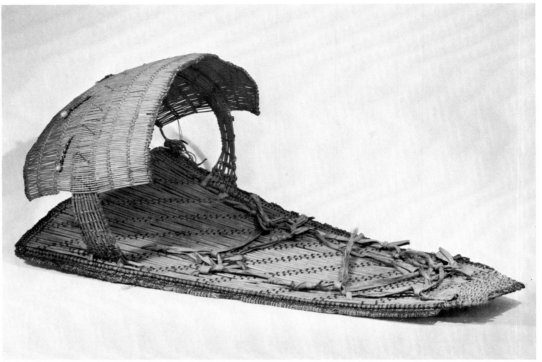

80

PANAMINT

The Panamint are a desert California hunting and gathering group which occupied
Death Valley and the two adjacent valley basins to the west—Panamint and Coso.
Though knowledgeable in the making of twined basketry, their coiled basket work
includes some of the most finely woven examples produced by American Indians,
with stitches commonly totaling as many as 30–40 per inch. Usually the
foundation consists of a single rod of willow with grass bunched around it. The
enclosing stitches are of thinly split willow for white background and of devil's
claw or of bulrush roots soaked in water and ashes for black.

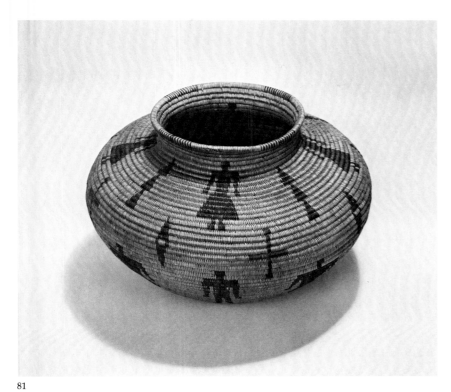

81

81
NECKED JAR
7¼" diameter, 5¼" high. This basket's very fine weave has 34 stitches to the inch. The clusters of vertical lines formed by alternating stitches of black and white on the last coil of the rim are a typical feature found in finely made Panamint baskets. Figures of men and women interspersed with geometric designs decorate the basket.

CHEMEHUEVI

Chemehuevi Indians occupied eastern portions of southern California, and those remaining are now near the Colorado River south of Parker, Arizona. Their notable, stiff, sturdy, coiled basketry has three rods of willow for foundation. Even stitches of split willow make up a white background against which the Chemehuevi weave designs in black, with devil's claw, and occasionally brown, with juncus. Highly prized for their simple, uncluttered designs and excellent craftsmanship, their baskets have been collectors items since before the turn of the century.

82
JAR-SHAPED STORAGE BASKET
6 3/8" diameter, 5 1/4" high. Coiled basket is of willow splints on a three-rod triangular foundation in the popular jar form. The black design of stepped lines with pendant triangles encircling the basket from the base to shoulder is in *martynia* or "devil's claw." *Martynia* is a weed similar to cocklebur and produces seed pods which have tentaclelike horns six to ten inches in length terminating in a sharp hook. The pod is black. The Chemehuevi use the outer coat of the horn in basketry.

83
SHALLOW BOWL-SHAPED BASKET
8 1/2" diameter, 2" high. Basket is of willow and black devil's claw coiled over a three-rod willow bundle. Note the right-handed or clockwise coiling technique. Decoration is in a popular motif: nine-pointed star in center surrounded by ten six-pointed stars. The black coil at the top is a common trait of Chemehuevi baskets.

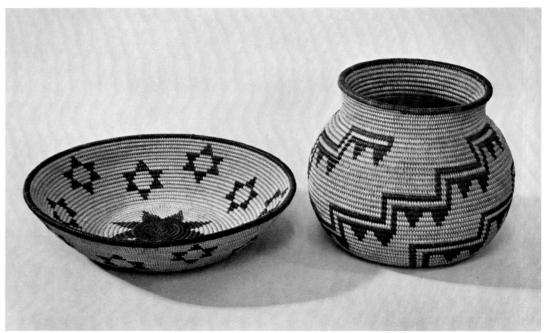

82 *right*, 83 *left*

MISSION

Mission basketry refers to the weaving, principally coiled, which the groups did who occupied the southern California region along the coast and immediately adjacent desert areas. Similarities of weave, design motifs, and materials make it difficult to differentiate the some half dozen major divisions, named, for the most part, after the Franciscan missions established in their midst during the late 1700's. Close examination and analysis of documented examples may make separation possible; this has been done effectively with those of the Chumash.

The Mission basket is easily recognizable by the stitching of the grass bundle foundation coils using the split stems of rushes. These rushes have a pleasing range of very light to dark tans and browns. A black achieved by a dyeing process

or by using devil's claw may supplement these subtly shaded effective designs. The weaving technique in Mission basketry is distinctive from that of other groups since it has the end of a stitch visibly tucked under successive stitches on the work surface.

Very simple band designs tended to be the decoration of early baskets, but later, with commercial outlets and influence, naturalistic forms became popular, especially the rattlesnake along with birds, butterflies, plants, and more complicated geometric patterns.

84
SHALLOW BOWL-SHAPED BASKET
See p. 30

85
LARGE STORAGE BASKET
See p. 30

86
STORAGE BASKET
See p. 30

87
STORAGE BASKET
See p. 30

88
SHALLOW STORAGE BASKET
See p. 30

89
OVAL-SHAPED STORAGE BASKET
12″ long, 10″ wide, 3¾″ high. Coiled basket has wide stitches of many shades of juncus. The somewhat cluttered design features a stylized flower motif in the bottom. This basket was obtained in 1906 in San Diego County.

90
STORAGE BASKET
12″ diameter, 5¾″ high. Coiled basket has counterclockwise start. There are various shades of juncus, which are woven into a stylized butterfly design interspersed with geometric starlike patterns in black.

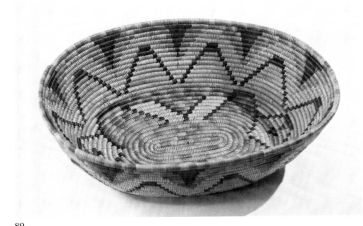

89

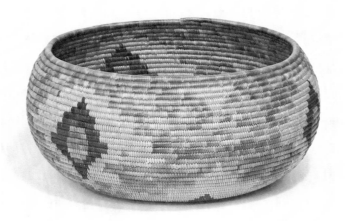

90

91
STORAGE BASKET
5½" diameter, 4¼" high. This is a finely coiled and highly decorated wide-mouthed storage jar. The motif on the upper body of the basket may be a diving bird. There is a floral motif in the lower portion with a six-pointed star or flower in the bottom center.

92
STORAGE BASKET
10¾" diameter, 4¾" high. Very fine coiled "rattlesnake" basket has the naturalistic snake design encircling the upper portion. Further decoration is a four-petaled flower on the bottom and triangular motifs dispersed below the shoulder of the basket. Since earliest times, weavers have made rattlesnake patterns; during the period between 1890 and 1940, numerous weavers among the Mission Indians used the rattlesnake patterns.

93
BOWL-SHAPED BASKET
14½" diameter, 4" high. Coiled basket has clockwise start. Construction is with various colored juncus strips woven in a swirled zigzag pattern, which may be a representation of lightning.

94
TWINED WATER BOTTLE
See p. 31

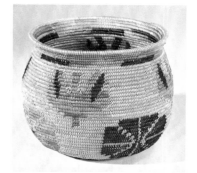

91

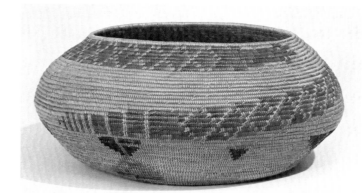

92

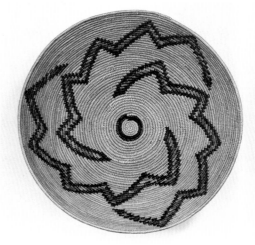

93

HOPI

The Hopi occupy mesa top adobe villages in northeastern Arizona, and although noted as pottery makers, they also have a thriving output of basketry. Basket makers are mainly in the western villages on second and third mesa. They weave by coiling and plaiting, using yucca over grass or shredded yucca bundles in the former baskets and rabbit brush or yucca in the latter.

The Hopi plait baskets either wholly with yucca strips or with rabbit brush wefts and wild currant warps. The flat baskets best serve as trays or sifters, but in more commercial contexts, they may hang as wall plaques. Deep baskets with flared sides of rabbit brush and native or aniline dyed designs are also decorative and useful items for sale. The Hopi employ coiling to make circular trays or plaques and variously sized storage baskets.

95
PLAQUE
14¾" diameter. Plaited basket from Third Mesa uses wild currant for warp and rabbit brush for weft, some of which has been dyed black, red, and yellow. To start the basket, the Hopi plaited together and crossed 2 sets of 5 bundles of wild currant, forming a hump in the center. Yucca finishes the rim. In their basketry, the Hopi use a wide variety of colors produced from various plants, blossoms, and roots. The design is a· large butterfly on a red background.

96
PLAQUE
11½" diameter. Plaited basket is of wild currant warp and rabbit brush weft dyed in various colors. The rim is of yucca. The design depicts a kachina mask. Kachinas are representations of deities important to Hopi religion. The Hopi hold ceremonial dances at which these gods are represented. Originally they made the round plaques specifically for ceremonial or household use, but the plaque style and designs made them popular commercial items. This plaque is from Third Mesa.

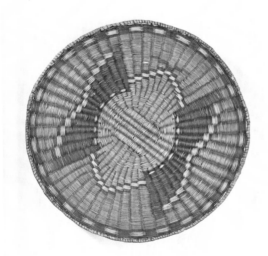

95

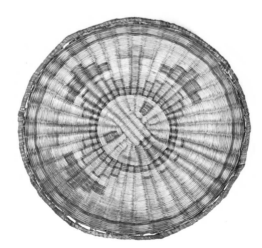

96

97
STORAGE BASKET
11½" diameter, 8½" high. Plaited basket is in a technique commonly called wicker weave. This basket is from Third Mesa. Its construction is in wild currant warp with rabbit brush weft. Yucca finishes the rim. The Hopi used native dyes for various colors in the weft materials which have been woven in a simple design. The Hopi developed deep baskets of this type to meet public demand.

98
PLAQUE
12¼" diameter. Coiled basket plaque is from Second Mesa. The foundation of galleta grass or shredded yucca has yucca strips as stitching. The decorative design is of conventional geometric figures.

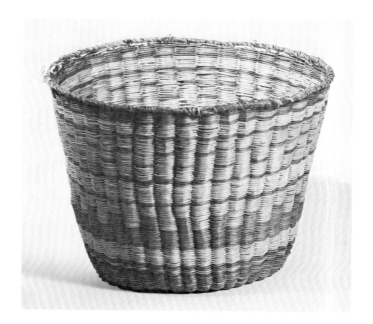

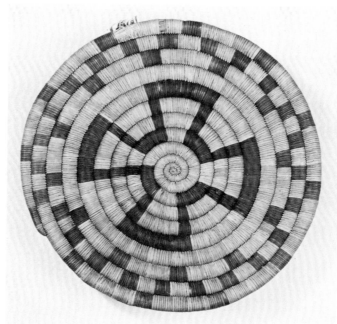

98

WALAPAI

The Walapai occupied a good portion of northwestern Arizona south of the Colorado River. They have produced a variety of baskets by coiling and twining, but have settled on making the latter now mainly by twill, 2 element S-twining. Made of sumac twigs, the baskets are bowl shaped for utility purposes. Because the Walapai do not carefully prepare materials to be of equal sizes, the finish is not as smooth or even as in baskets of other groups, but the baskets are strong and durable. The Walapai sometimes use aniline dyes to produce the simplest of lines for decoration.

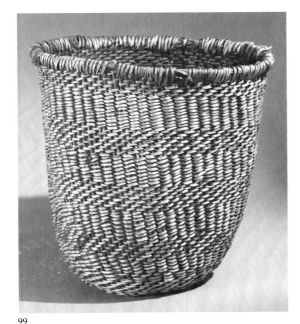

99

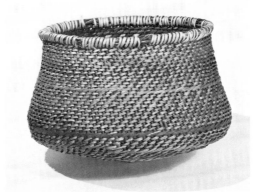

100

99
TWINED STORAGE BASKET
10" diameter, 10¾" high. Weave is plain, 2 element S-twined with double warps and twill, 2 element S-twined. The alternate series of plain and twill twined weft rows along with changes in color create a decorative effect. The material is sumac, which grows abundantly on the Walapai reservation. The weaver placed sticks around the rim and wrapped them securely in place.

100
SMALL STORAGE BASKET
8" diameter, 4¾" high. Weave is twill, 2 element S-twined with 3 elements introduced at the base and center for strength and decoration. The basic material is sumac twigs. At the center of the body, a different, barklike material appears as a second weft element to form a simple line design of alternating stitches above and below. To add strength, the weaver wrapped a bundle of small twigs around the rim.

NAVAJO

The Navajo are the principal occupants of northeastern Arizona and extend into the adjoining states. Though knowledgeable in basket making, they rely increasingly on such neighboring tribes as the Ute, Paiute, and Apache to supply them with the baskets they need, in particular, the ceremonial baskets, the most common being the one used in weddings. The latter basket is a coiled shallow bowl or tray with a characteristic circular band design flanked by a series of triangles; a single line opening or break exists in the circle. The rim has false braid herringbone pattern woven around it.

101
WEDDING BASKET
12½" diameter, 4¼" high. Coiled basket is of natural and dyed sumac stitches over a three-rod triangular foundation of willow. Ute Indians probably made this basket. The rim's finish is in the false braid weave. The basic colors of wedding baskets are white, natural; red, reddish brown; and black. The triangular designs are said to represent hills and valleys of this world and the underworld. The means of communication between the two worlds is called "shipapu." The break in the circular design represents this; hence spirits may come and go between the worlds. According to tradition, the end of the coil must line up with this break; this provides an easy method of locating the "shipapu" which must face east during ceremonies. Prior to 1900, sometimes the Navajo inverted these baskets during ceremonials for use as drums. The drum sticks were of yucca leaves wrapped and sewn together.

102
WEDDING BASKET
11¾" diameter, 2" high. Coiled basket has sumac stitches over a three-rod willow foundation. The rim is herringbone. The design and colors are typical of Navajo wedding baskets, including the break in the circular design. During the wedding ceremony, traditional food and sacred pollen, the Navajo symbol of fertility, are placed in the basket according to set traditional patterns, and the bride and groom exchange portions to consecrate the marriage.

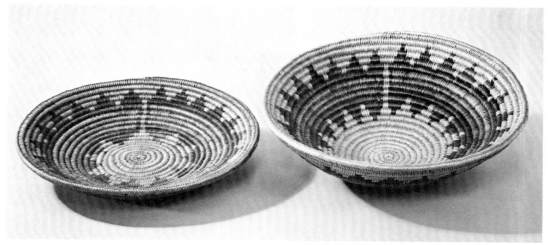

101 *right,* 102 *left*

APACHE

The Apache ranged over a wide territory extending from central Arizona into much of New Mexico. They are subdivided into three groups: the Mescalero in southern New Mexico, the Jicarilla in northern New Mexico, and western Apache groups (San Carlos and White Mountain) in Arizona.

The best baskets of this group are those of the western Apache who wove principally coiled trays and storage baskets and twined burden baskets made from willow and cottonwood with black devil's claw used in design elements. Geometric forms employing triangles as well as human and animal representations were popular.

Mescalero Apache coiled baskets have three rods held side by side to form a flat coil; their sewn stitches are from the yucca plant. Aniline dyed yucca strips are used to decorate some baskets in simple geometric designs.

The Jicarilla Apache coiled baskets have a rather rough weave and are made of willow or cottonwood. The designs worked in with aniline dyed stitches tend to fade greatly, especially when exposed to strong sunlight.

103
WIDE-MOUTH JAR-SHAPED
STORAGE BASKET
7½" diameter, 8" high. Basket has a three-rod foundation of willow with stitches of split cottonwood and devil's claw for decoration. Figures of animals were favorite motifs of the western Apache. Usually they chose the symbols and figures for designs for decorative purposes only, without any symbolic meaning. They probably made a jar of this size for sale because it is too small for storage of grain or food. Western Apache.

104
SMALL STORAGE BASKET
7" diameter, 3½" high. On a foundation of three rods of willow, the maker wove white cottonwood and dark brown devil's claw into an attractive geometric design. It is probable that the geometric designs of Apache baskets are older than those of zoomorphic or anthropomorphic figures. Western Apache.

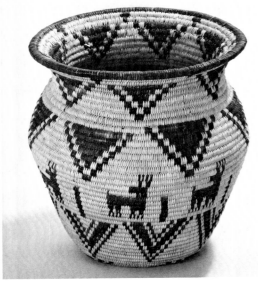

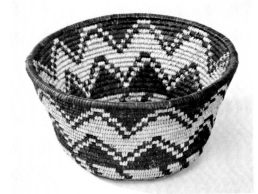

103 104

105

SHALLOW BOWL OR TRAY

19¼" diameter, 3" high. Coiled on a willow foundation, the basket has cottonwood and devil's claw stitches forming a striking pattern. The design features an interesting arrowhead motif around the rim pointing to the center star design. The star was a popular motif which may have originated as a Yavapai design. Other geometric designs scattered throughout the pattern add to the basic motif. The three-rod triangular formation of the foundation makes each coil stand out separately and is easily visible in this tray. Western Apache.

106

SHALLOW BOWL OR TRAY

15½" diameter, 2" high. Coiled basket has foundation of willow with cottonwood and devil's claw stitching. The central design, surrounded by diamonds around the rim, is a variant of the sun motif. A black center start is one characteristic of Apache baskets. Western Apache.

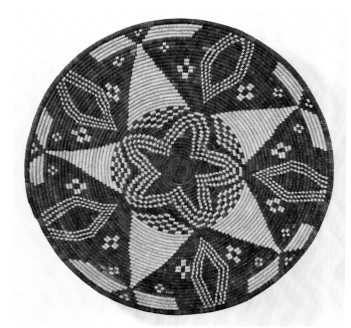

105

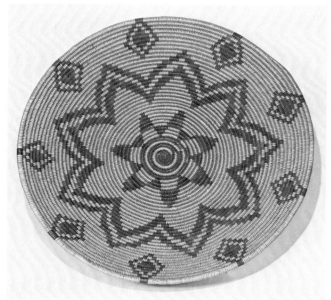

106

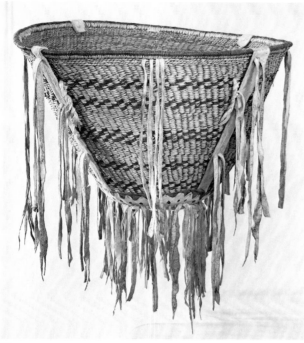

107

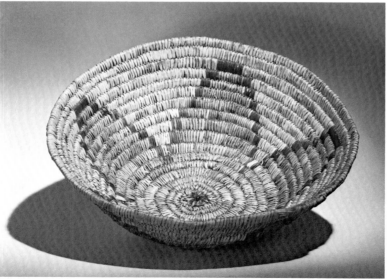

108

107
BURDEN BASKET
18¾" long top, 16¼" wide top, 12" high. Basket weave is plain, 2 element S-twined with double warps. Woven of willow, basket has devil's claw decoration. Three rows of plain, 3 element S-twining finish the rim. In typical fashion, decoration is with buckskin fringe; on the bottom of the basket, the maker has sewn buckskin cut in a scalloped and eyelet pattern and red cloth. The Apache used these baskets to gather wild foods, such as seeds, berries, walnuts, and piñon nuts, and to carry wood and other supplies to camp. A carrying band or tumpline, attached to reinforcing rods inside the basket, passed around the forehead to support the basket on the back. Western Apache.

108
SHALLOW BOWL
12¼" diameter, 4" high. Wide pieces of cottonwood form the flat foundation of this coiled basket stitched with split yucca. The five-pointed star in red and yellow dyed fibers is a popular design. Mescalero Apache.

109
SHALLOW BOWL OR TRAY
17½" diameter, 4" high. Irregular thicknesses of willow form the foundation around which split yucca stitches are sewn. The maker used varying shades of yucca to make an indistinct, now faded, star within a star motif. *Mescalero Apache.*

110
SHALLOW BOWL
16¾" diameter, 5" high. Coiled basket has willow foundation with yucca stitches. The design of triangles and paired merging crosses is in red and green aniline dyed fibers. The weave of the rim is false braid or herringbone stitch. Jicarilla, the name given this tribe by the Spanish, means "basket." Apparently at the time of contact, they were making many baskets. *Jicarilla Apache.*

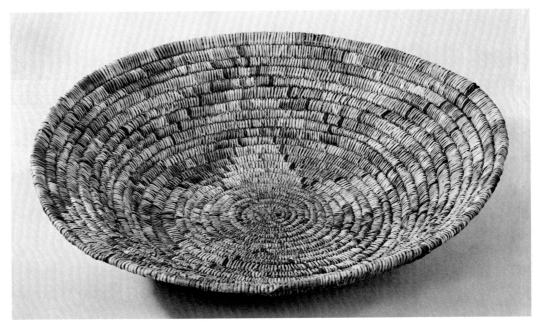

109

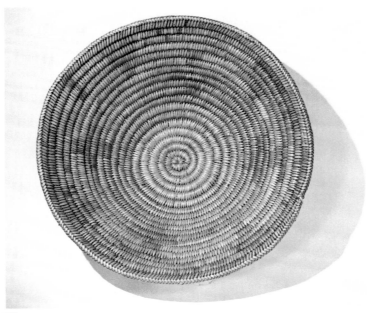

110

PIMA

The Pima, located in southern Arizona, are noted for their coiled baskets which are strong and useful, yet also display gracefulness of shape, diversity of pattern, and great beauty. Some collectors believe they excel all other baskets. The Pima form coils from split tule or occasionally cottonwood splints and in turn wrap or stitch these with split willow for white decoration and devil's claw for black decoration. The basket usually starts by a plaited "knot" of devil's claw and finishes with a braided rim. Designs are mainly geometric patterns in swirl or quadrant layout.

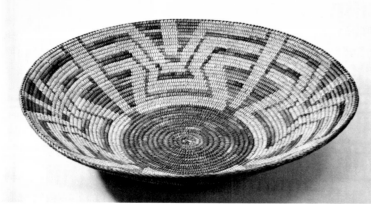

111

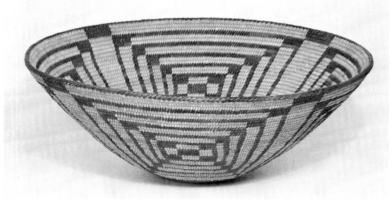

112

111
SHALLOW BOWL
16¾" diameter, 3½" high. Coiled basket is of willow and devil's claw over a foundation of tule. One distinguishing feature of Pima baskets is a braided rim. The design is a "butterfly wings" motif, a beautiful old pattern woven in variations ranging from four to six sections.

112
BOWL WITH FLARING SIDES
15¼" diameter, 5¾" high. Coiled basket has a tule foundation with stitches in willow and devil's claw. Braided rim is typical. The design depicts the traditional "turtle back" motif, seen by observing the concentric rectangle forms. The shallow bowl-shaped trays were sometimes called wheat baskets because of their use in winnowing the grain or for catching the ground wheat, which would be made into pinole or tortillas.

113
SHALLOW BOWL
15¾" diameter, 3¼" high. Willow and devil's claw stitching is over a foundation of tule. There is a braided rim. The unusual design element is an original composition in quadrant form with a suggestion of a bird with outstretched wings. Original designs, in the true sense of the word, are not common as most motifs are based on such traditional designs as fretwork, squashblossom, whirlwind, mazes, and swastikas.

114
STORAGE BASKET
6½" diameter, 4½" high. Coiled basket is of willow and devil's claw over a foundation of tule. There is a braided rim. The design suggests a net covering, or possibly chicken wire fencing inspired it.

115
STORAGE BASKET
13¾" diameter, 12¼" high. Tall storage basket is of willow and devil's claw coiled over a foundation of tule. There is a braided rim. The netlike design is identical to that of the small storage basket.

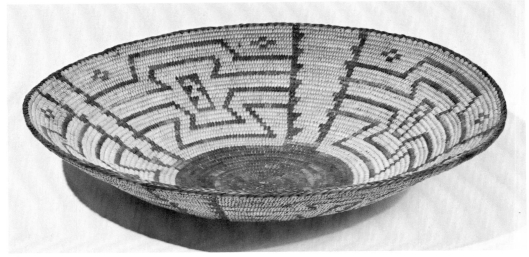

113

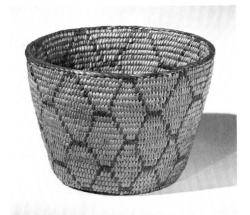

114

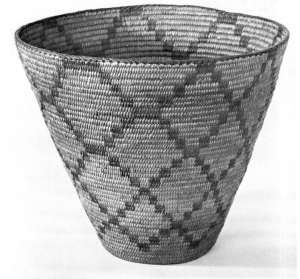

115

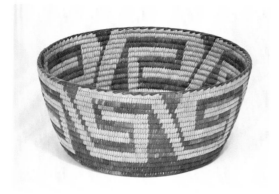

116

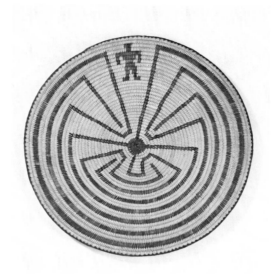

117

116
STORAGE BASKET
9¼" diameter, 4½" high. Devil's claw and willow stitching is over a tule foundation. A diagonal border overcast stitch finishes the rim. The fret motif is one of the oldest and most common designs among the Pima. It appears in many variations, and although it closely resembles the Greek fret, it is unlikely that they reproduced it from the Greek fret.

117
PLAQUE WITH MAZE DESIGN ("THE LABYRINTH")
15½" diameter. Coiled foundation of tule is with willow and devil's claw stitching. There is a braided rim. The Pima have made many examples of this maze design. Although this design is depicted on Grecian coins uncovered in Crete, the origin of the Pima design is thought to be local rather than European since a maze occurs on the inside wall of Casa Grande ruin, Arizona, and there is a legend associated with the design.

PAPAGO

The Papago are another group occupying southern Arizona. In early times, their coiled basketry was strongly similar to that of the Pima. Since the 1890's, however, commercialization caused changes which make it easier to distinguish Papago work from that of their neighbors. Yucca replaced willow, and bear grass became the core of the coil.

The wider leaves of the yucca do not require as much sewing, and the coarser stitch does not allow for very intricate geometric designs; all this saves much time for the weaver and allows an increase in production. Today the Papago probably make more baskets than any other tribe, and their basketry production is one source of income for them. Animal and plant forms have become favorite decorative elements. Since it is pounded as it is woven, the surface of the coil of the yucca basket tends to be flatter and wider.

118
LARGE JAR-SHAPED
STORAGE BASKET
21" diameter, 25" high. Yucca and devil's claw stitches cover bear grass foundation. The central design is an encircling band of men and women holding hands. Meandering lines and other geometric motifs complete the decoration.

119
JAR-SHAPED STORAGE BASKET
8¼" diameter, 9" high. Yucca and devil's claw stitching is over a foundation of bear grass. The animals and human forms decorating the basket are in acrobatic positions; perhaps the forms illustrate circus figures. The Papago may have developed the designs in response to commercial demands.

120
STORAGE BASKET
11¾" diameter, 7" high. Bear grass foundation is with yucca and devil's claw stitching. Rim is of diagonal overcast stitching. The design in devil's claw shows outstretched forms of mice alternating with two "coyote track" motifs, one above the other. The latter design symbolizes the tracks of one of the most common desert animals. All materials used by the Papago for their baskets were in the natural colors without dyeing, but heavy use or exposure to sunlight caused fading.

121
STORAGE BASKET
7" diameter, 6" high. Coiled basket of yucca and devil's claw is over a foundation of bear grass. One motif is that of a lizard which abounds in Papago territory; it is a popular representation. The animal designs are stylized and strangely camellike in appearance. In the late 1800's, the U.S. government imported camels for use of cavalry units in the Southwest desert on an experimental basis which was not successful.

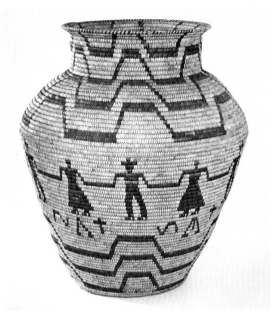

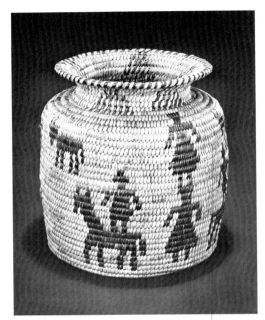

118

119

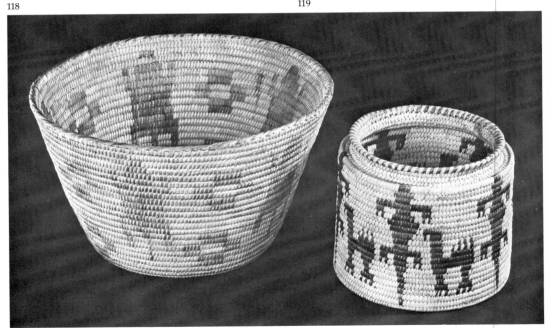

120 *left*, 121 *right*

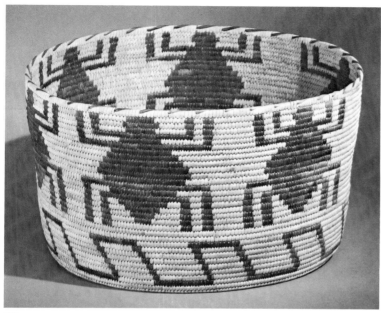

122

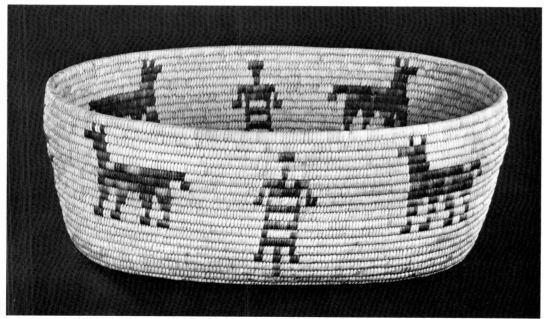

123

122
CYLINDRICAL BASKET
13½" diameter, 8" high. Basket is coiled with yucca and devil's claw over a foundation of bear grass. This example illustrates well the technique of pounding each coil with a hammer or smooth stone; a very flat wall surface is in contrast to the usual corrugated finish common to most coil baskets. The predominant design represents the tarantula, a common desert spider.

123
OVAL-SHAPED STORAGE BASKET
21½" long, 12¾" maximum wide, 7¾" high. Yucca and devil's claw stitches are over a foundation of bear grass. Stylized zoomorphic figures suggestive of horses and lizards comprise the design. In response to commercial demands, the Papago weave baskets in a variety of forms, not just in traditional shapes.

124
CYLINDRICAL BASKET
See p. 32

BIBLIOGRAPHY

Barrett, S.A. 1908. "Pomo Indian Basketry." *University of California Publications in American Archaeology and Ethnology*, vol. 7, no. 3, pp. 133–306. University of California, Berkeley, California.

Boas, Franz; Haeberline, H.K.; Teit, James A.; and Roberts, Helen H. 1928. "Coiled Basketry in British Columbia and Surrounding Region." Bureau of American Ethnology, *Annual Reports 1919–1924*, 41st, pp. 119–484. Washington, D.C.

Breazeale, J.F. 1923. *The Pima and His Basket.* Arizona Archaeological and Historical Society, Tucson, Arizona.

Goddard, Pliney E. 1903. "Basketmaking," pp. 38–48 in Life and Culture of the Hupa. *University of California Publications in American Archaeology and Ethnology*, vol. 1, no. 1, pp. 1–88. University of California, Berkeley, California.

James, George Wharton. 1902. *Indian Basketry.* 2nd ed. Henry Malkan, New York, New York.

Kroeber, A.L. 1905. "Basket Designs of the Indians of Northwestern California." *University of California Publications in American Archaeology and Ethnology*, vol. 2, no. 4, pp. 105–164. University of California, Berkeley, California.

Lamb, Frank W. 1972. *Indian Baskets of North America.* Riverside Museum Press, Riverside, California.

Mason, Otis T. 1904. "Aboriginal American Basketry: Studies in Textile Art Without Machinery." *Report of the U.S. National Museum, 1902*, pp. 169–548. Washington, D.C.

Mohr, Albert, and Sample, L.L. 1955. "Twined Water Bottles of the Cuyama Area." *American Antiquity*, vol. 20, no. 4, pp. 345–354. University of Utah Press, Salt Lake City, Utah.

O'Neale, Lila M. 1932. "Yurok-Karok Basket Weavers." *University of California Publications in American Archaeology and Ethnology,* vol. 32, no. 1, pp. 1–58. University of California, Berkeley, California.

Paul, Frances. 1944. "Spruce Root Basketry of the Alaska Tlingit." United States Indian Service, Education Division, *Indian Handcrafts*, no. 8. Washington, D.C.

Roberts, Helen H. 1929. "Basketry of the San Carlos Apache." American Museum of Natural History, *Anthropological Papers*, vol. 31, part 2, pp. 121–218. New York, New York.

Robinson, Bert. 1954. *The Basket Weavers of Arizona.* University of New Mexico Press, Albuquerque, New Mexico.

Rozaire, Charles E. 1959. "Analysis of Woven Materials from San Clemente Island." Department of Anthropology and Sociology, University of California Archaeological Survey at Los Angeles, *Annual Report 1958–1959*, pp. 157–163. Los Angeles, California.

———. 1969. "The Chronology of Woven Materials from the Caves at Falcon Hill, Nevada." *Nevada State Museum Anthropological Papers*, no. 14, pp. 180–186. Carson City, Nevada.

———. 1974. "An Analysis of Woven Materials from Seven Caves in the Lake Winnemucca Area, Pershing County, Nevada." *Nevada State Museum, Anthropological Papers*, no. 16, pp. 60–97. Carson City, Nevada.